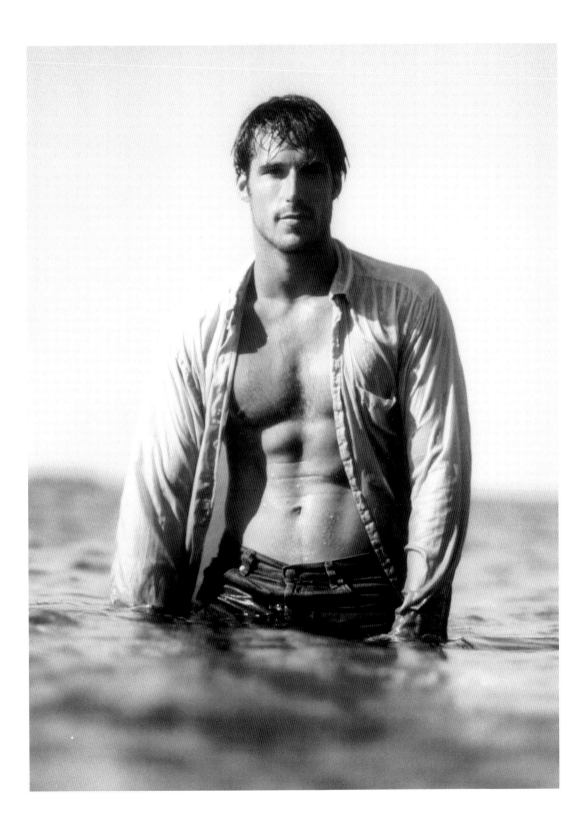

TO GREG.

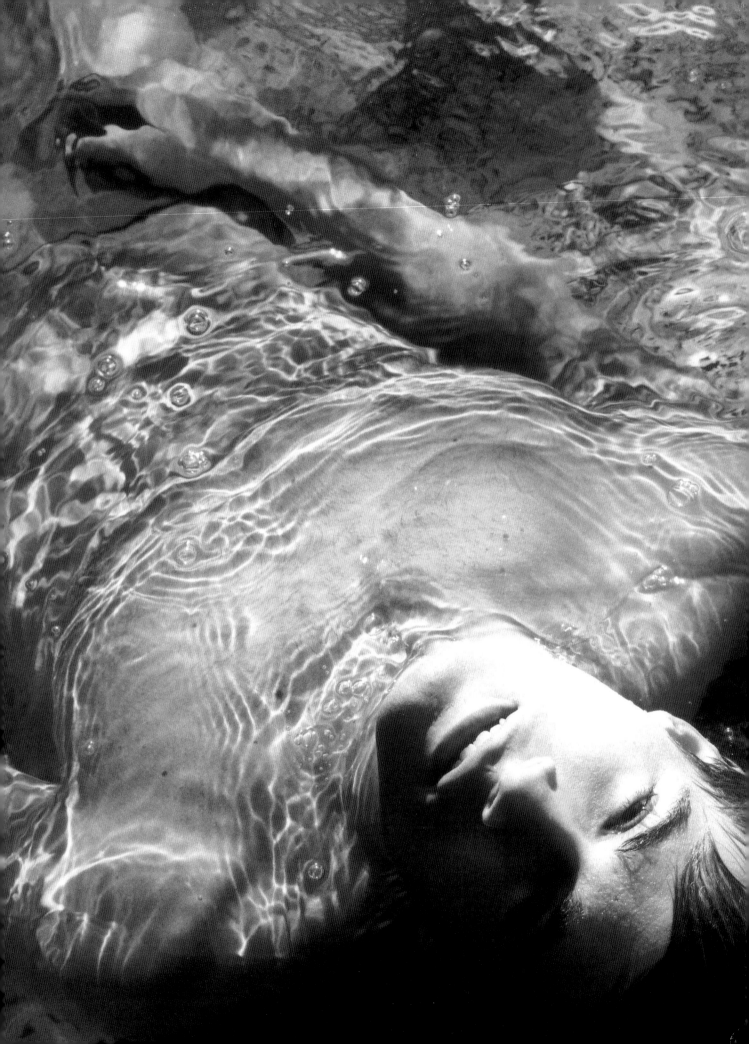

FRED.GOUDON.**AQUA**.

BRUNO GMÜNDER

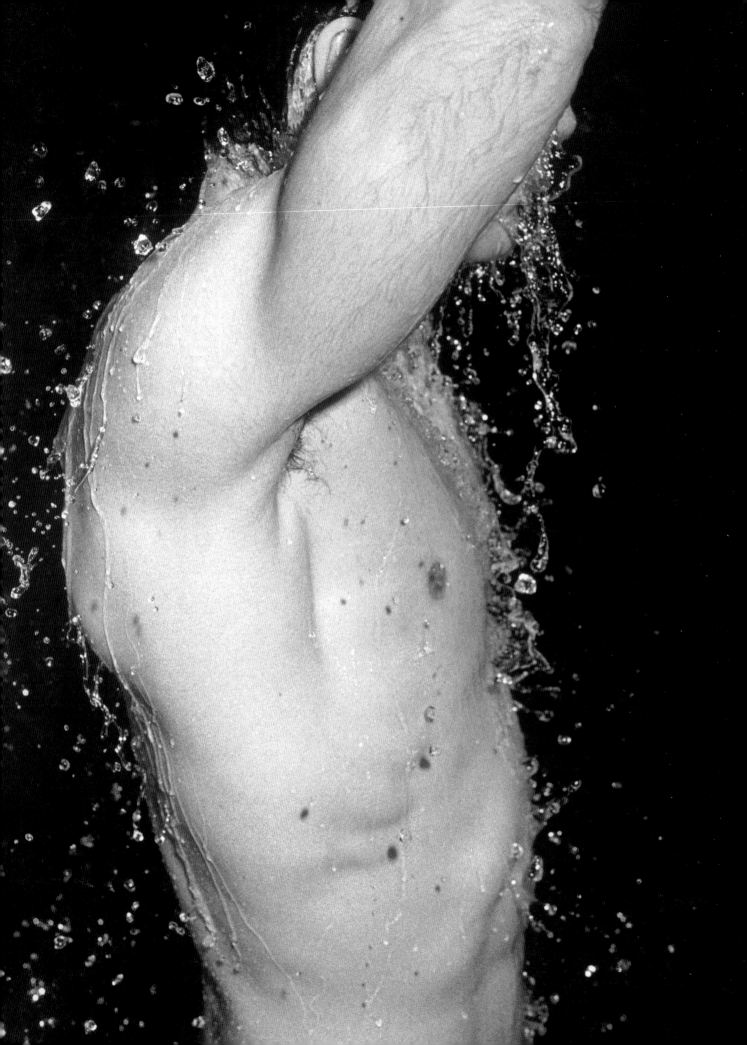

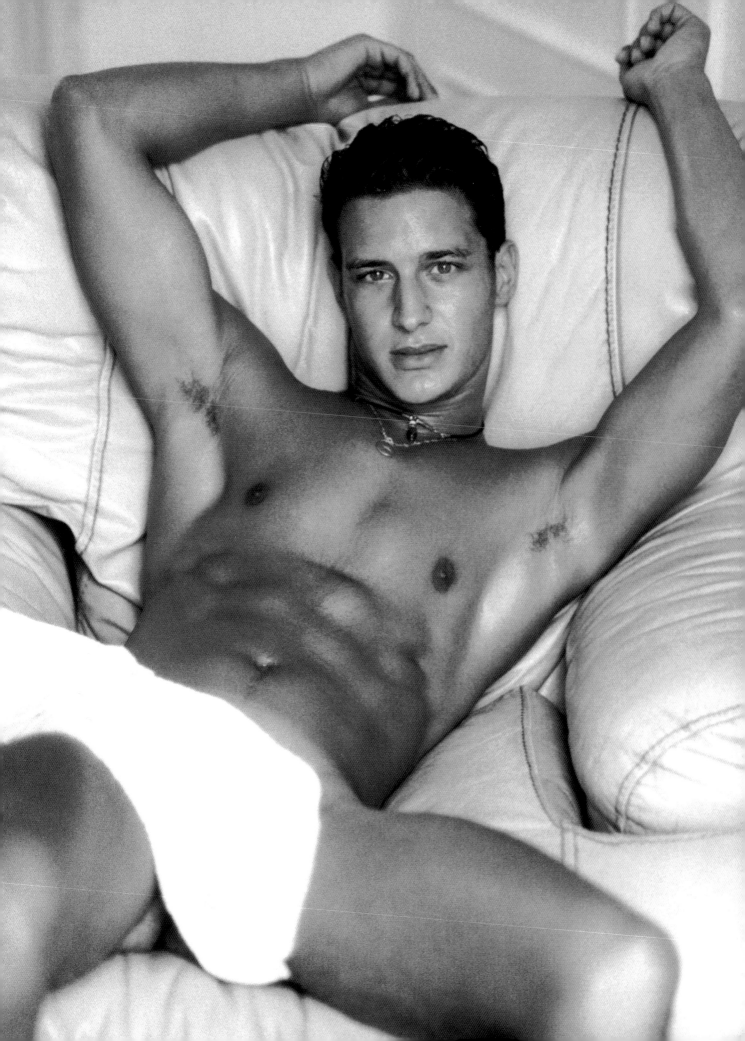

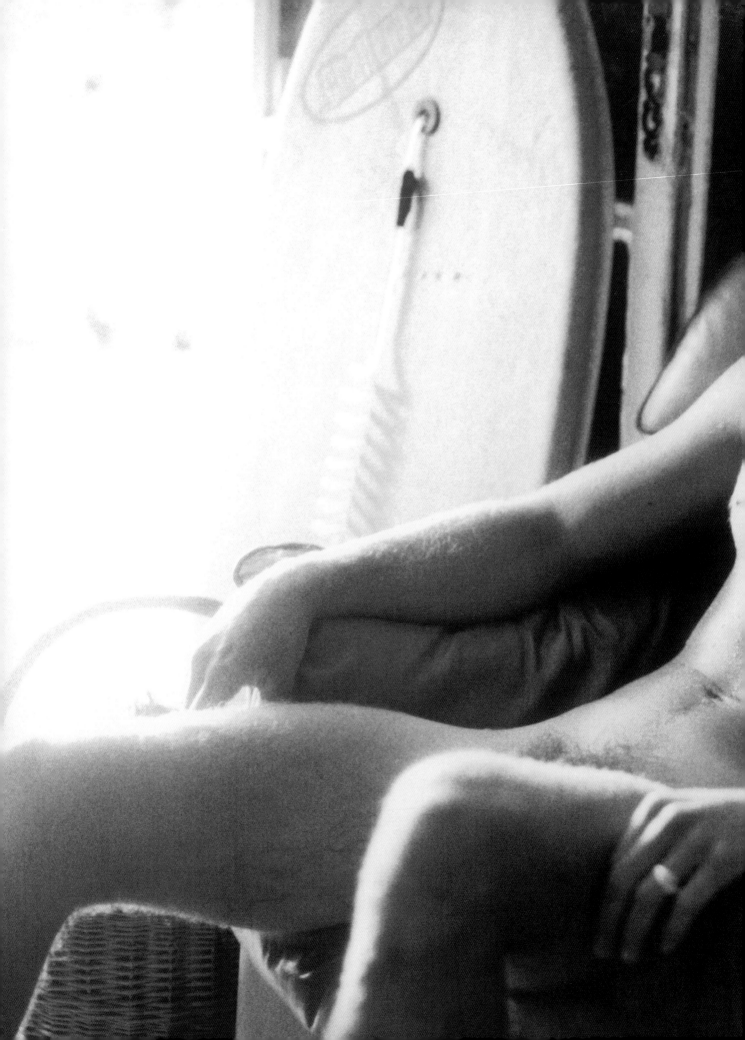

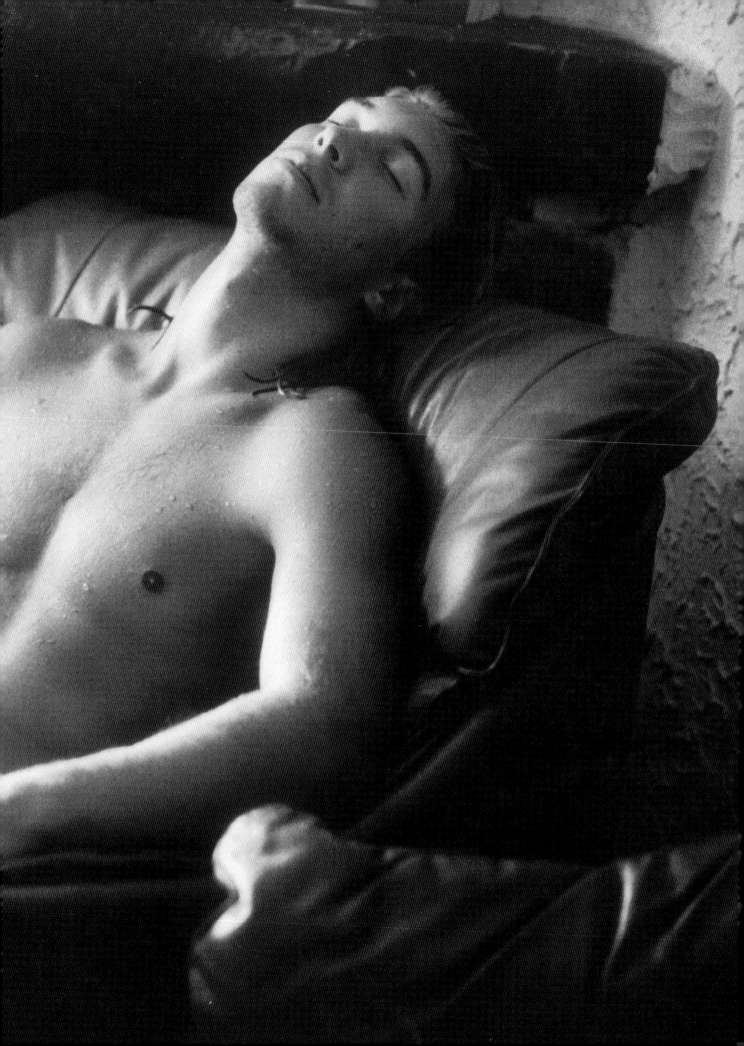

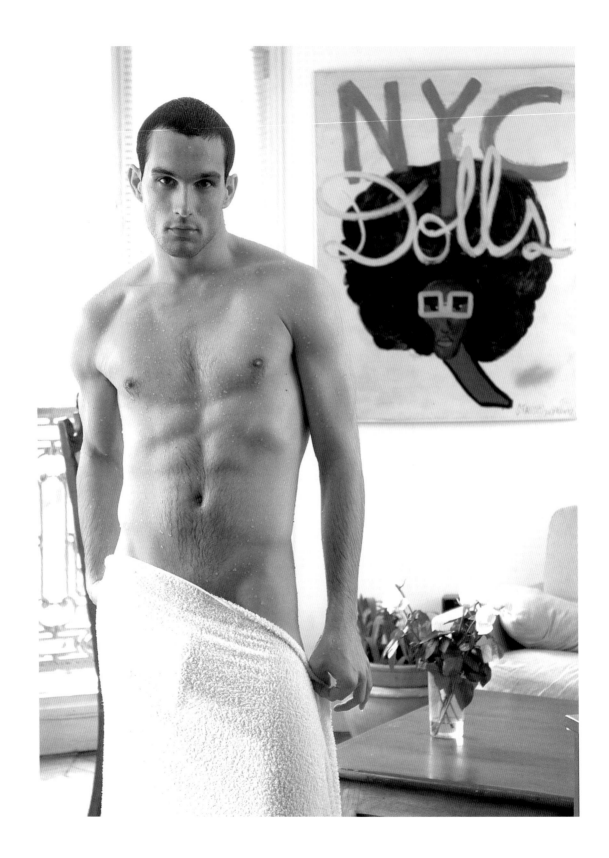

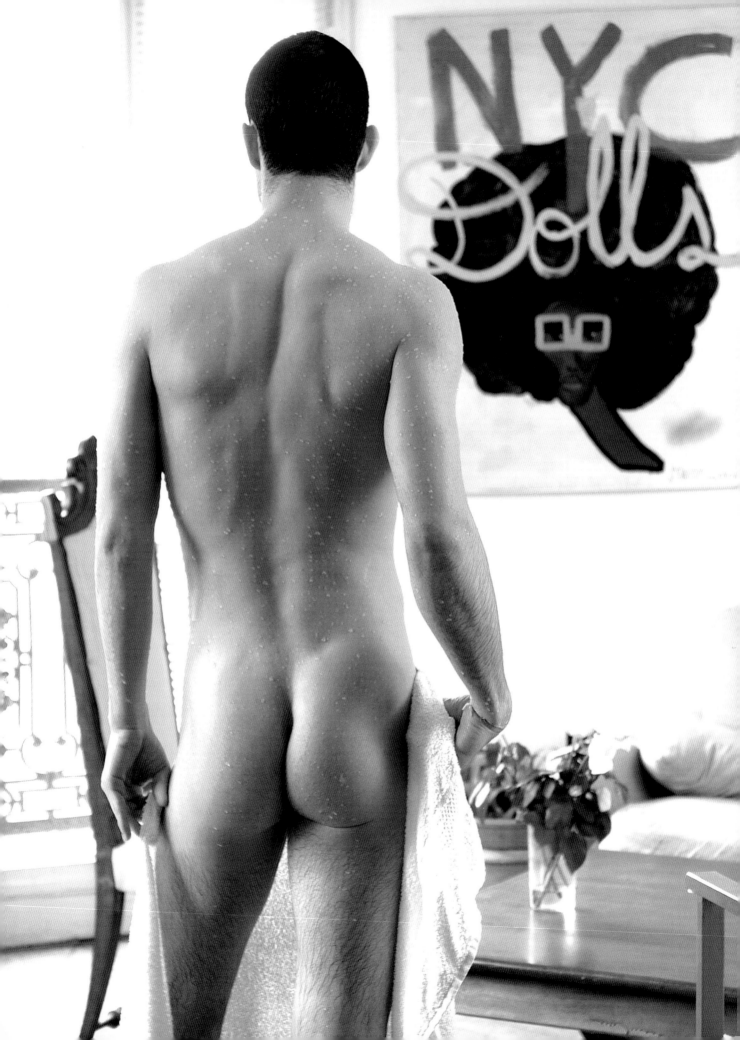

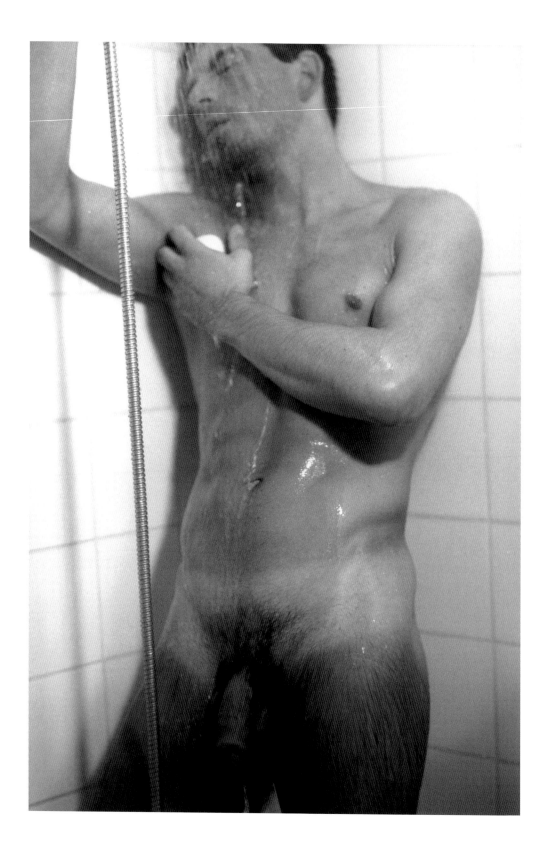

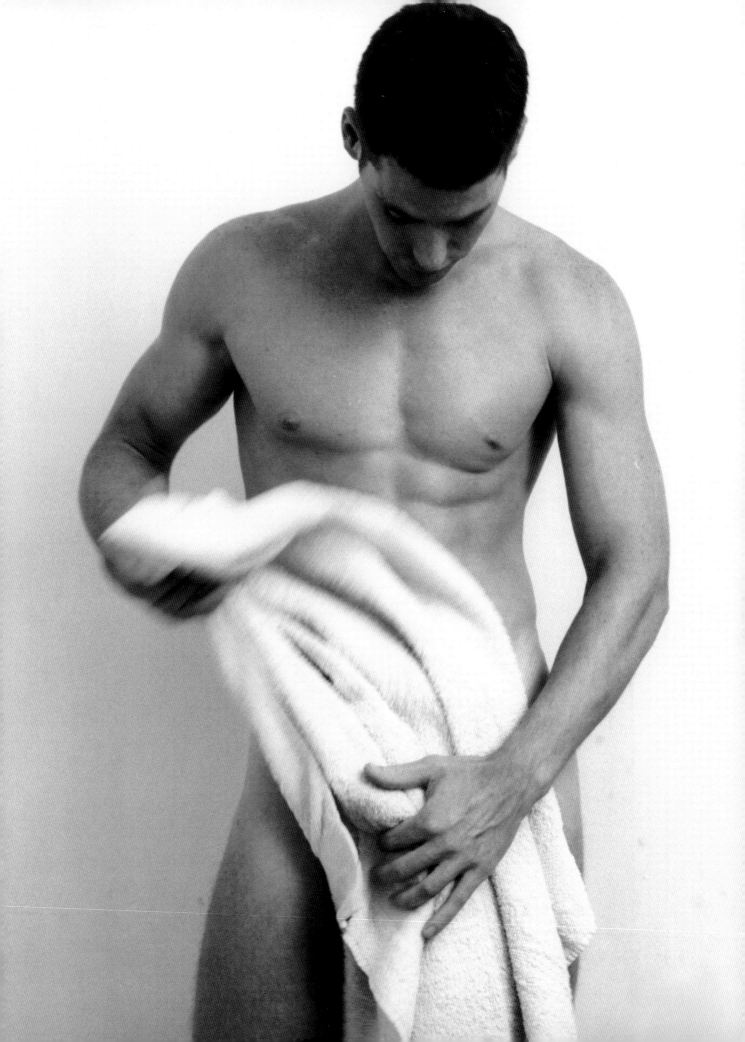

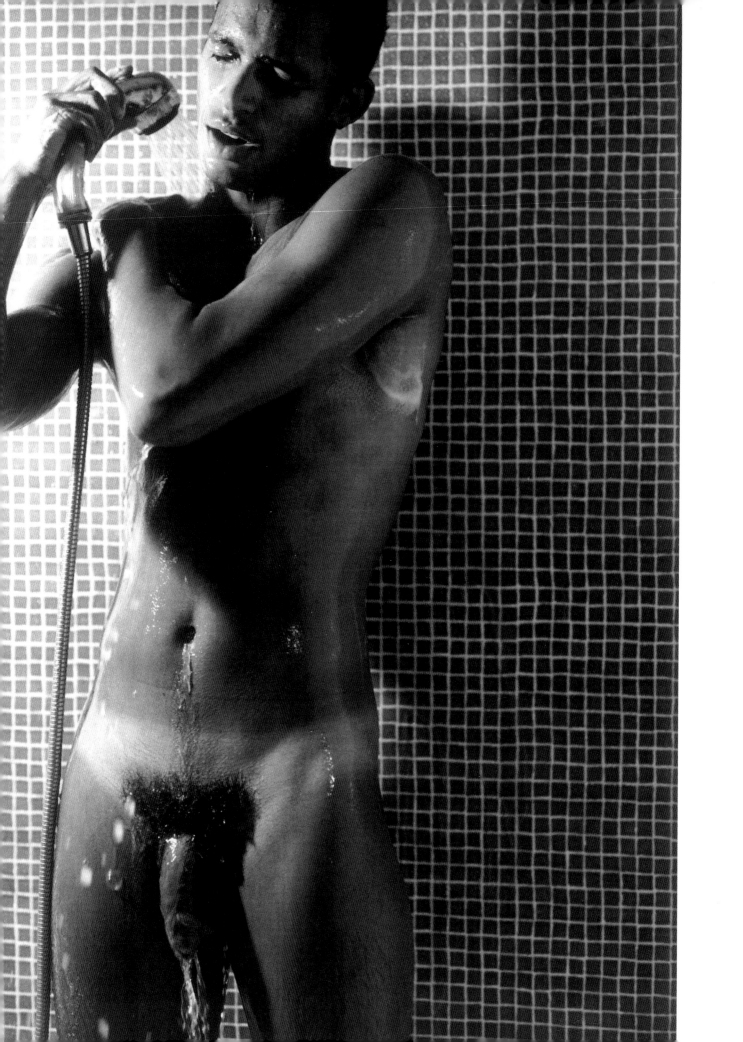

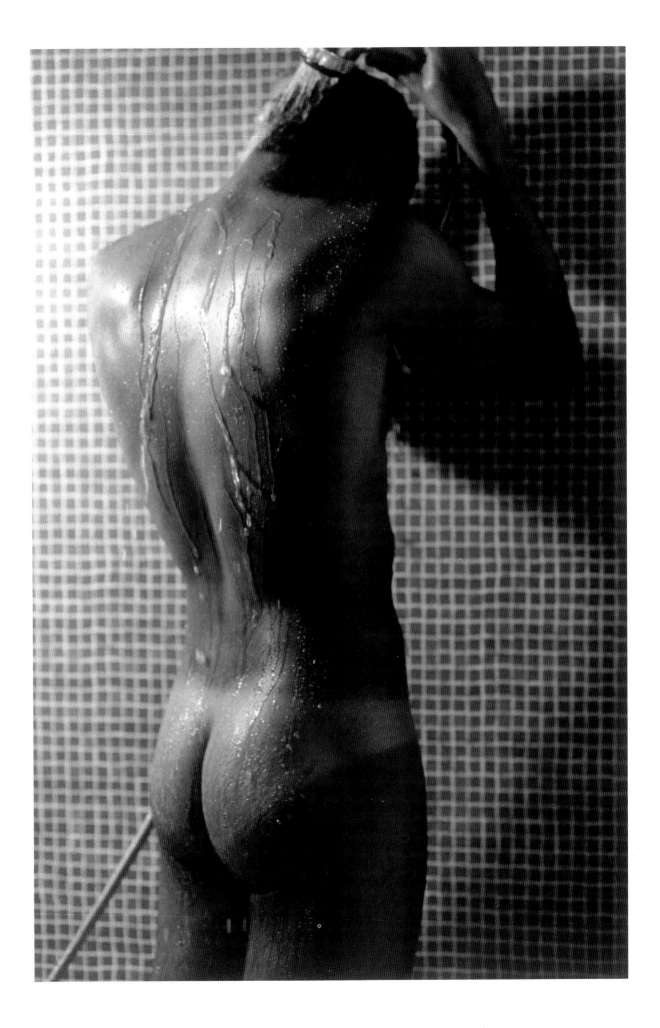

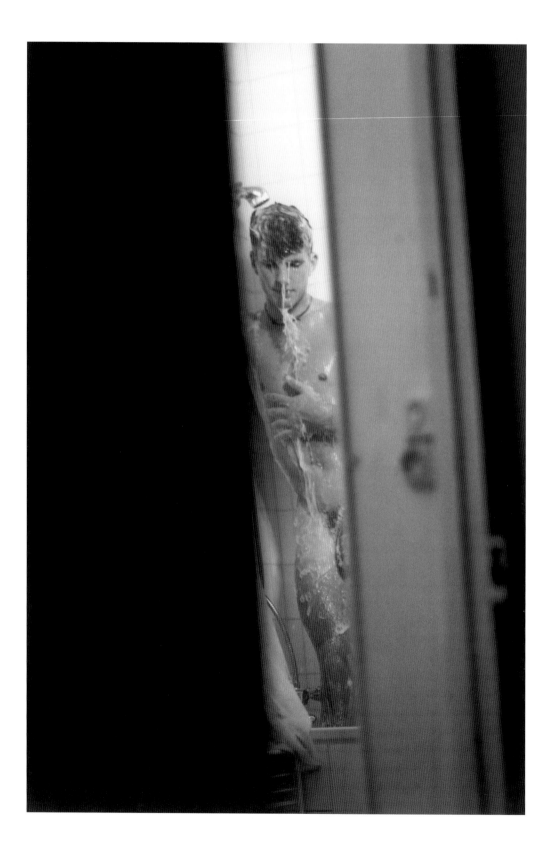

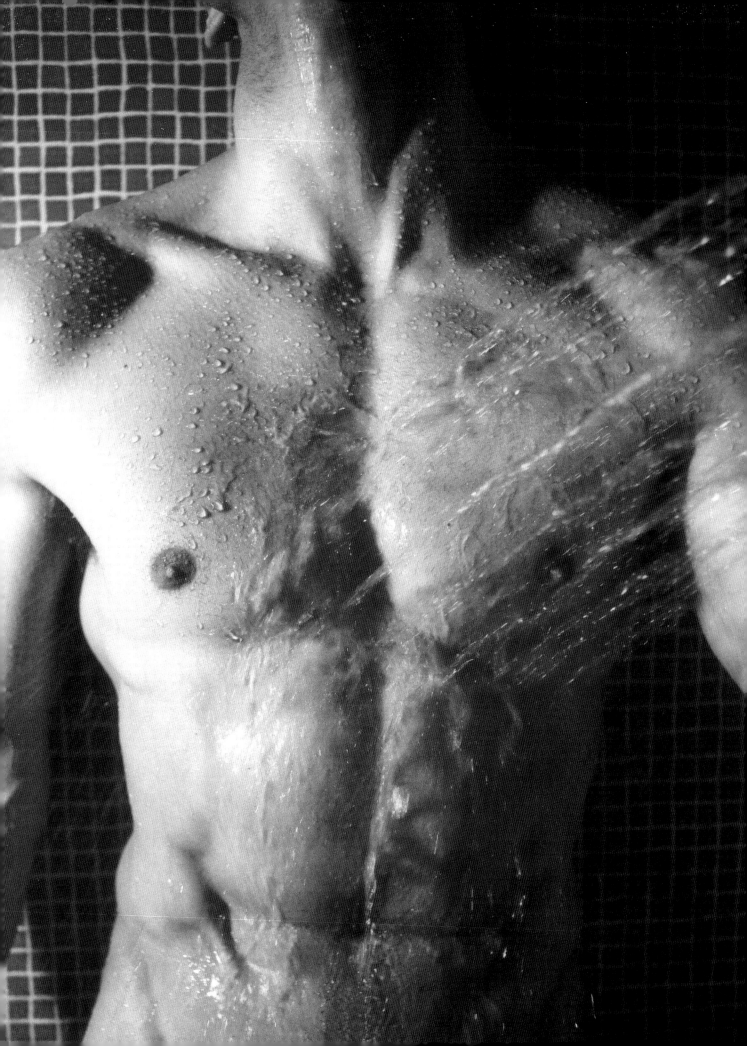

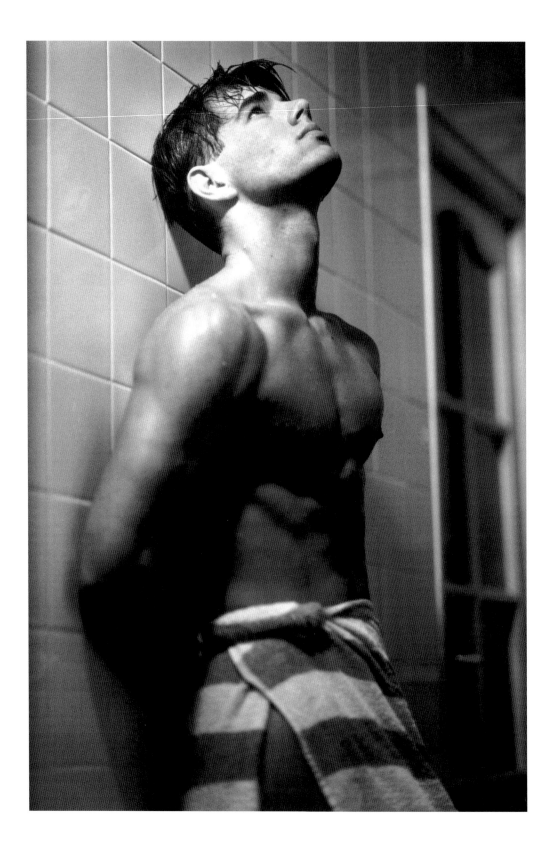

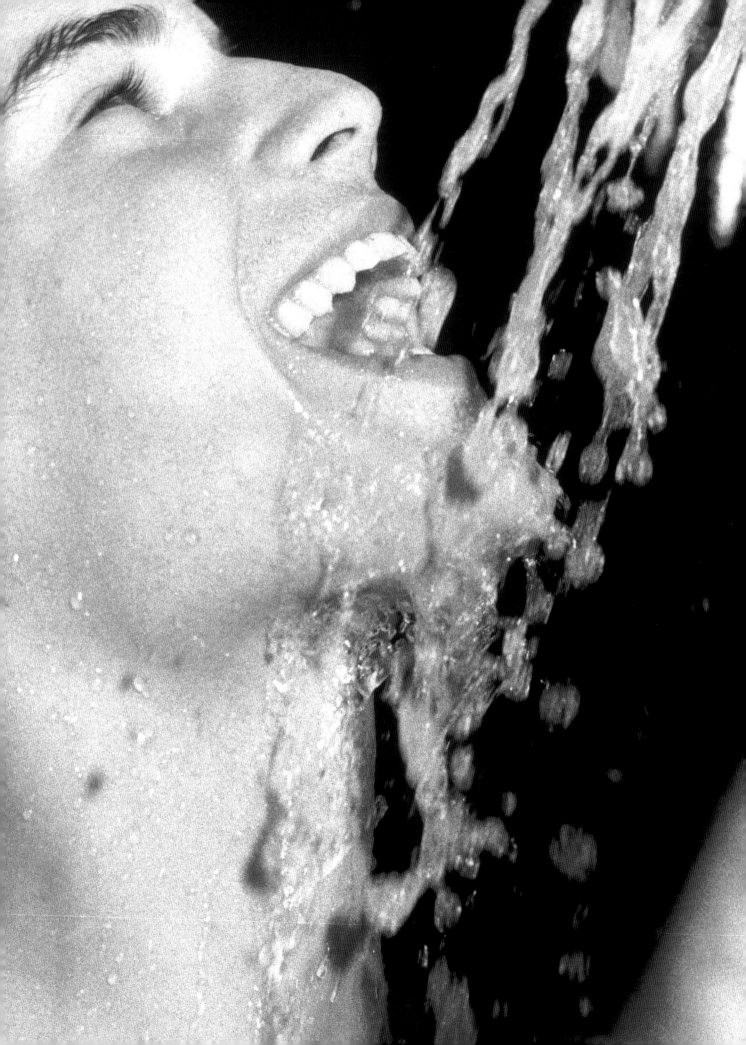

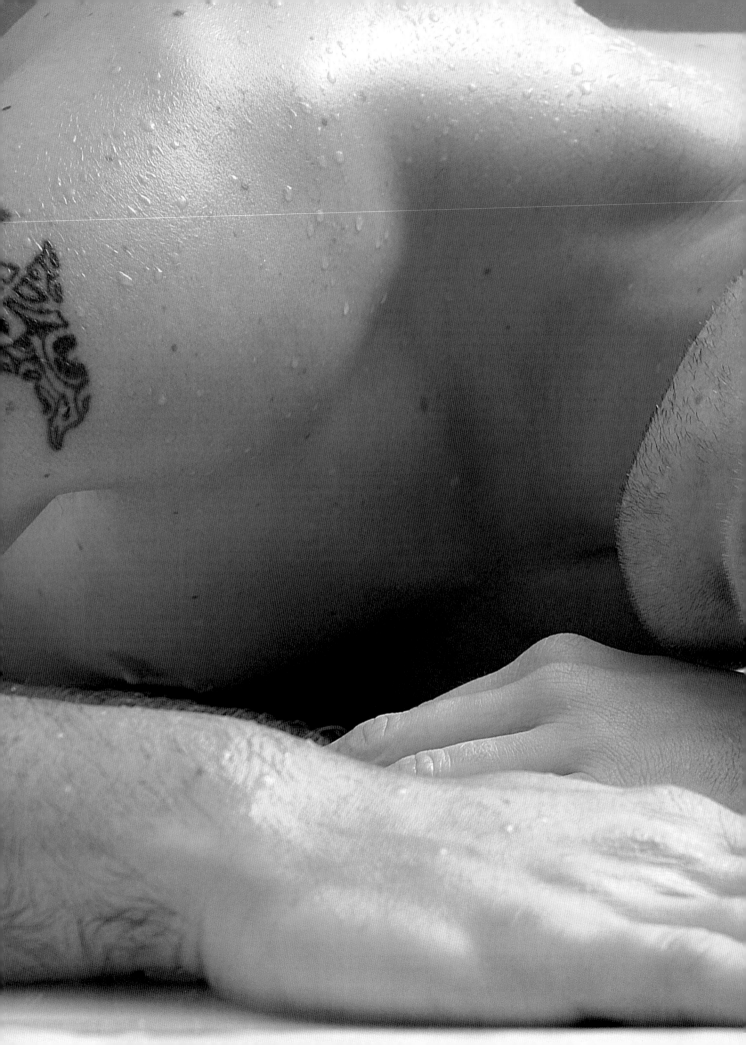

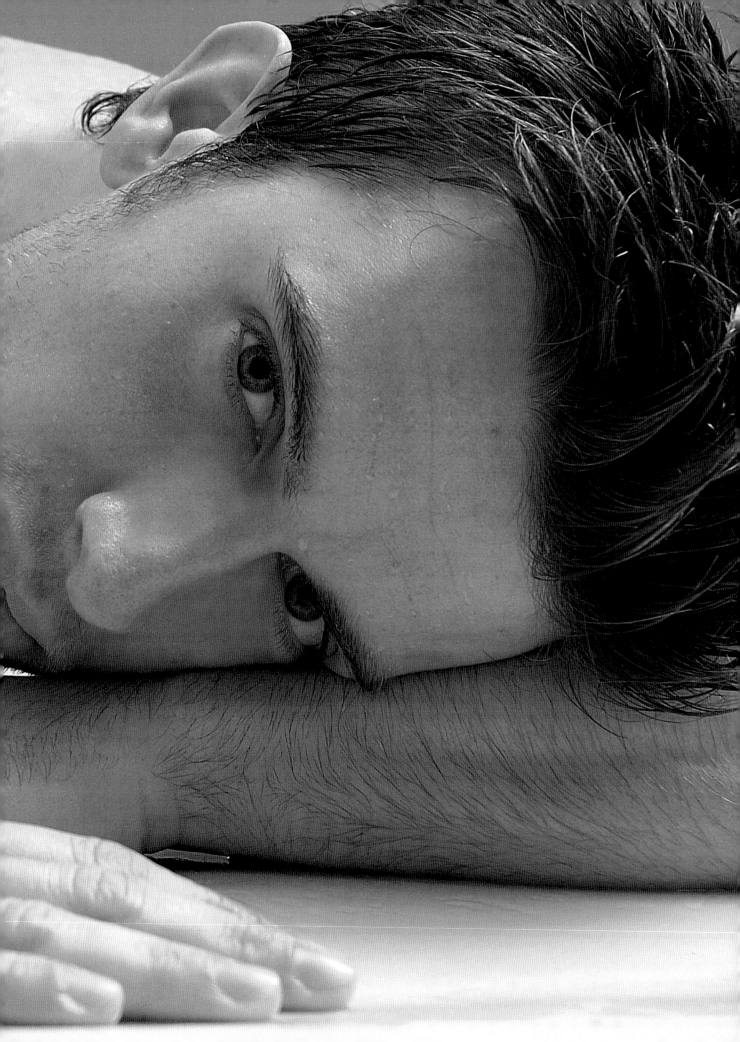

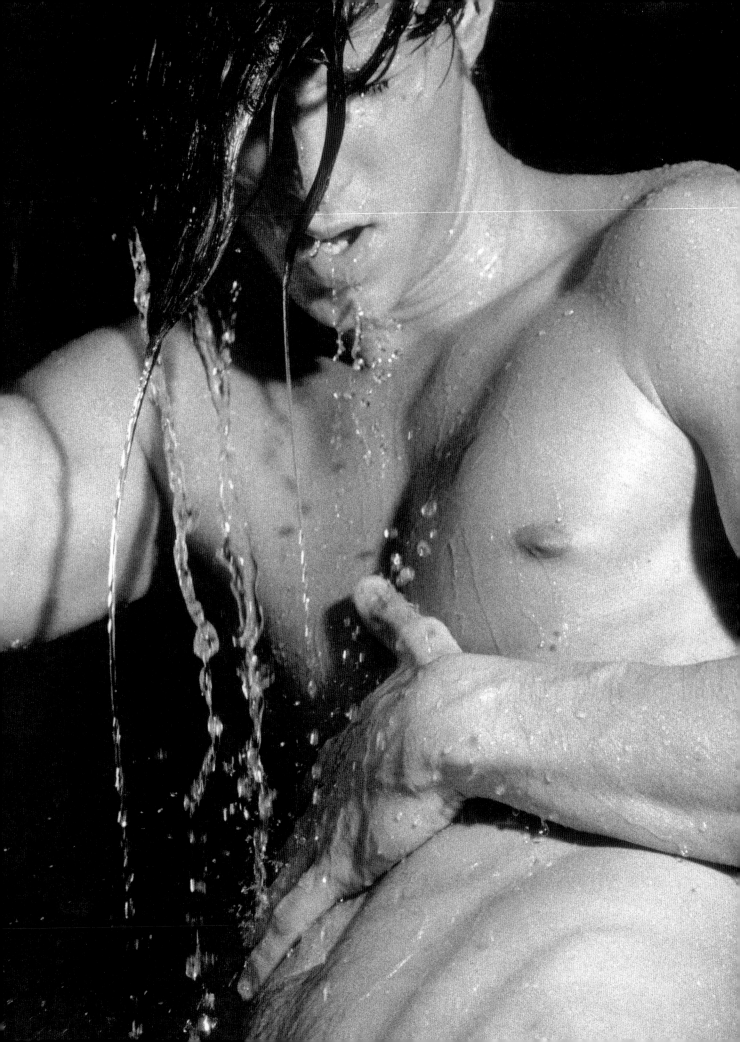

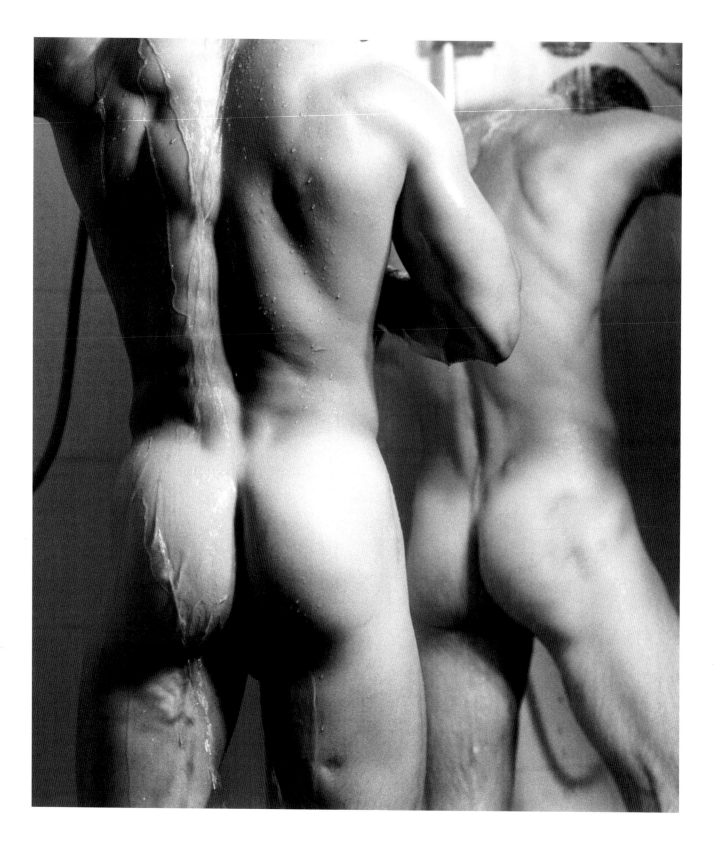

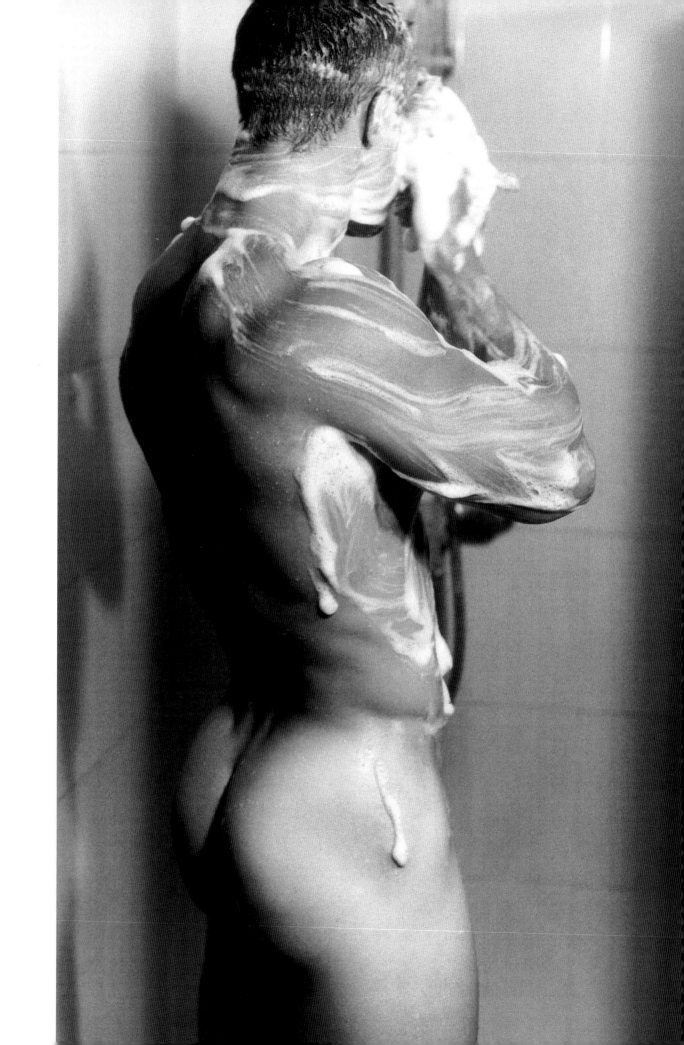

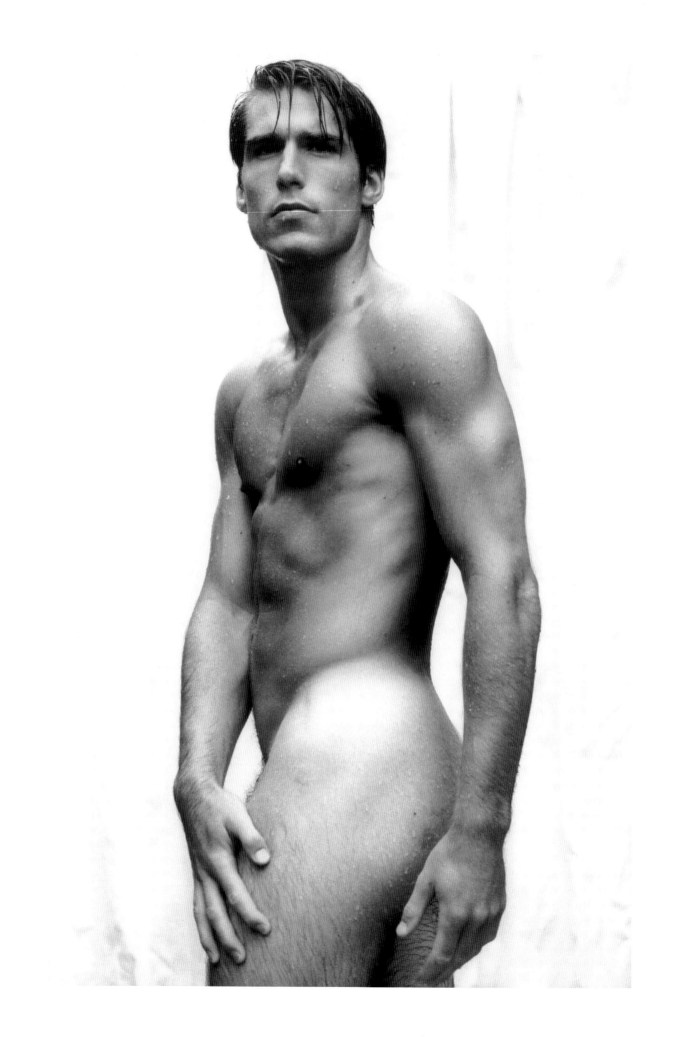

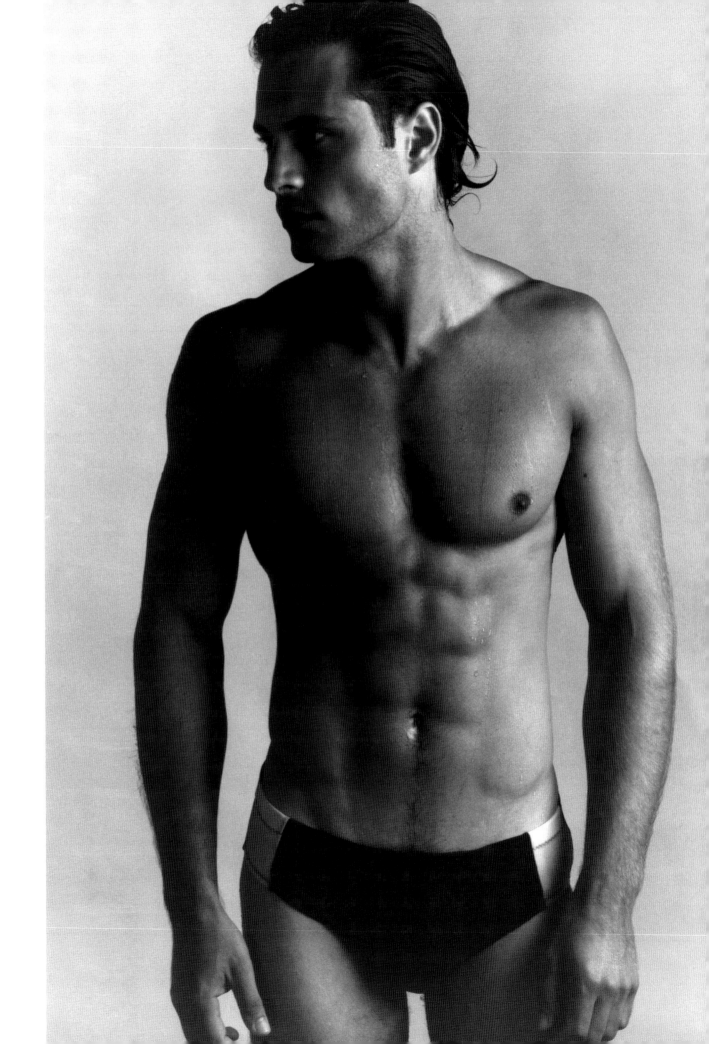

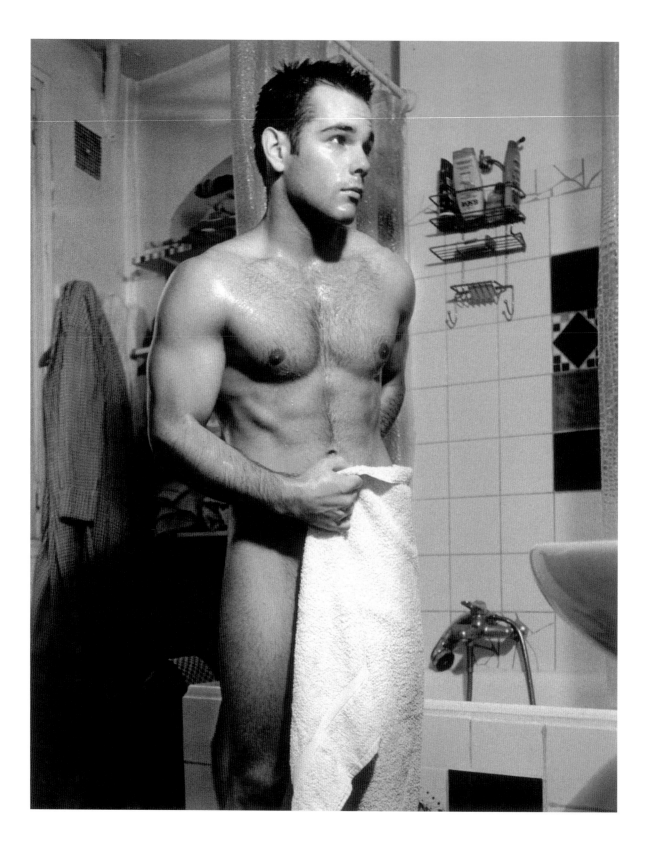

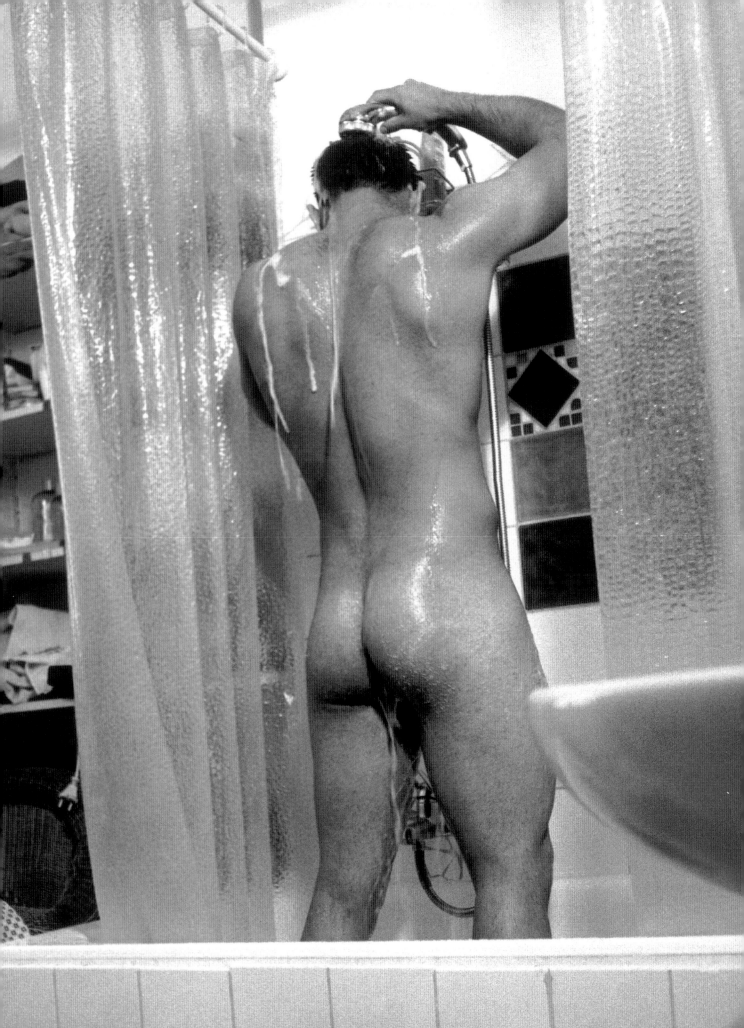

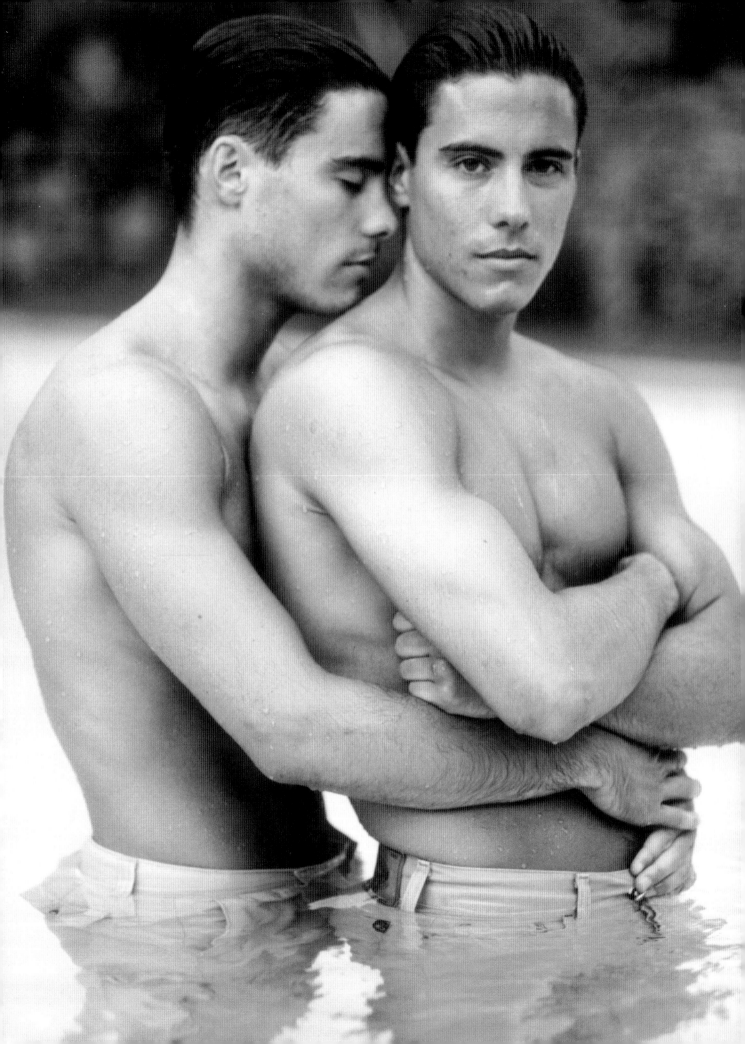

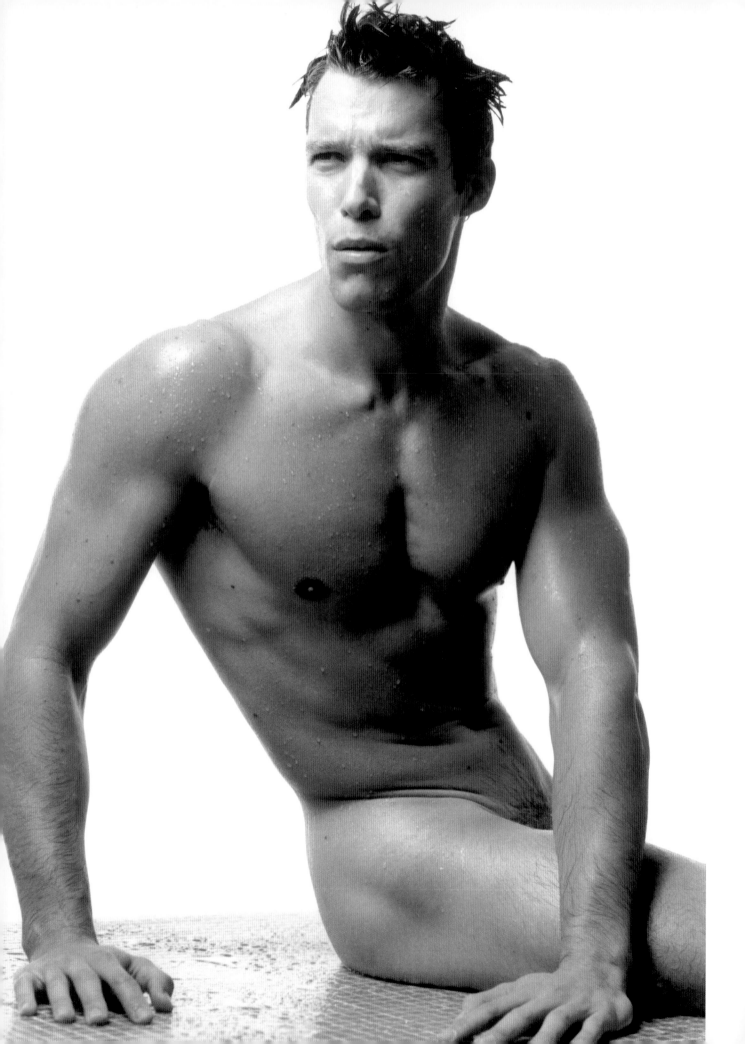

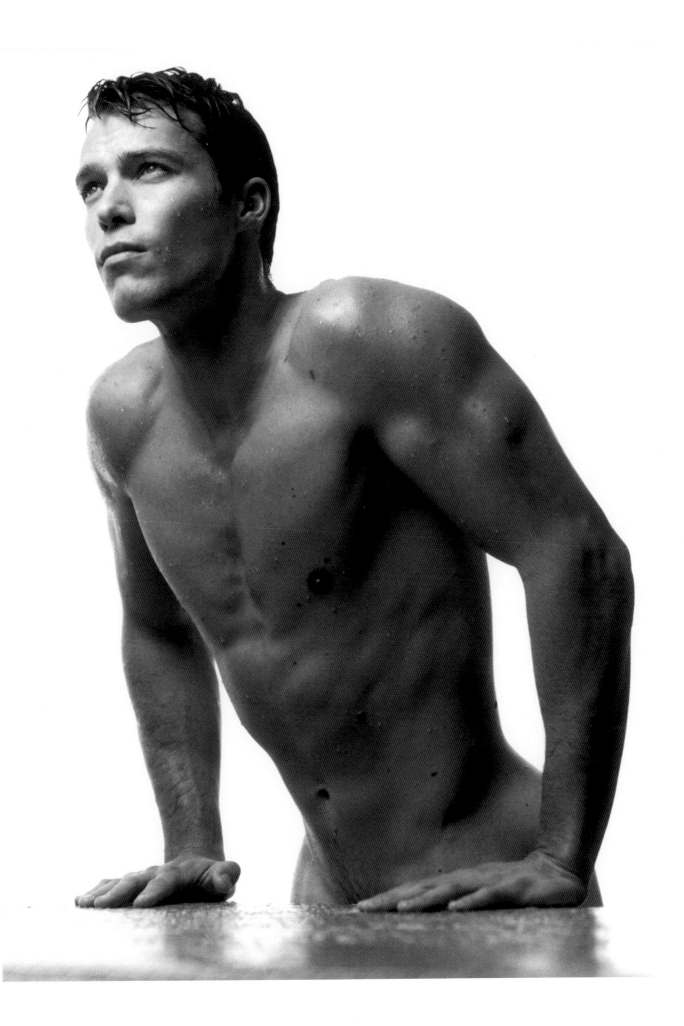

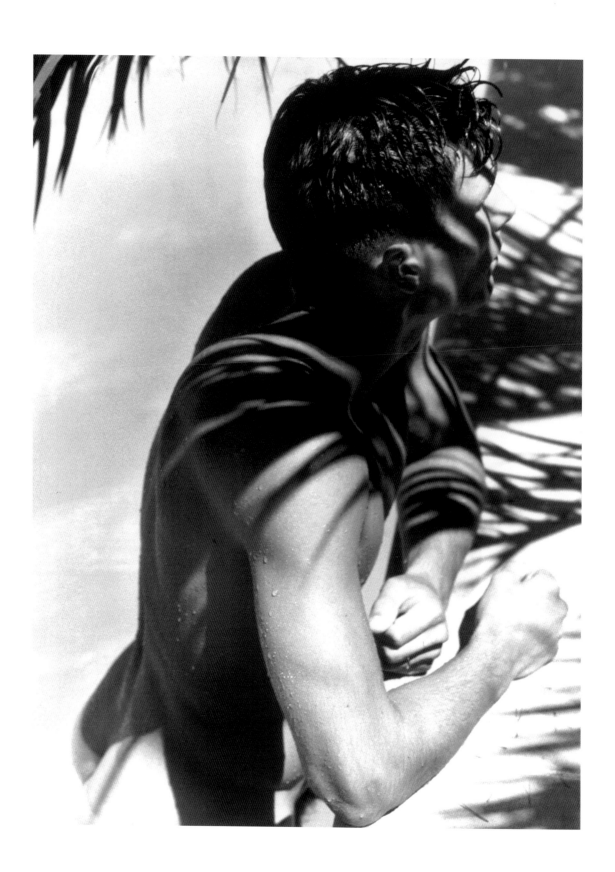

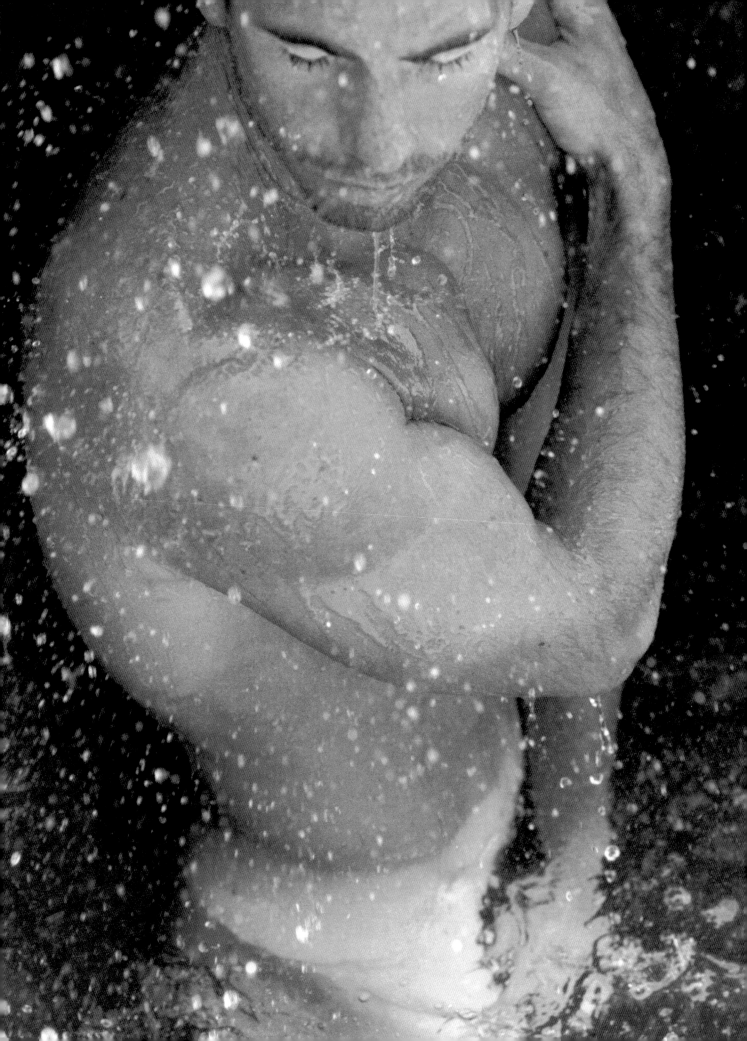

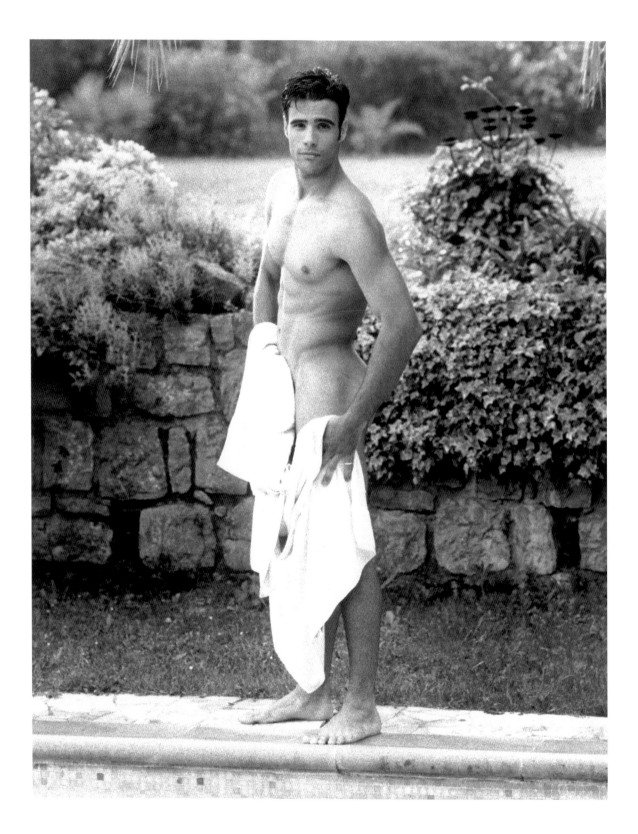

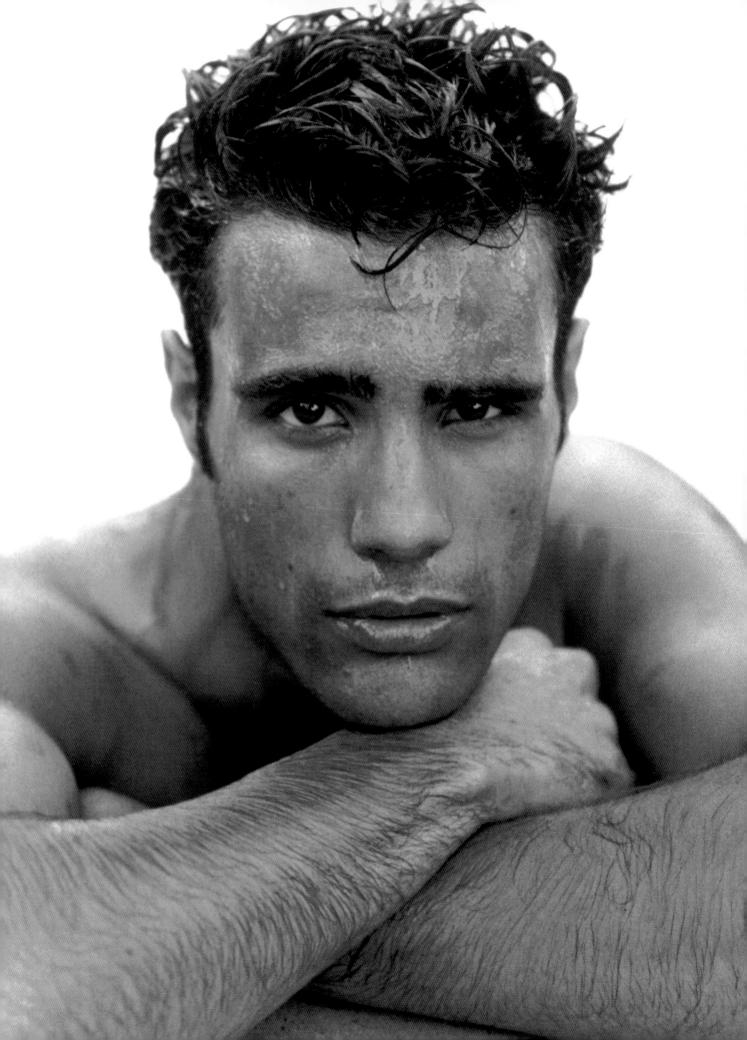

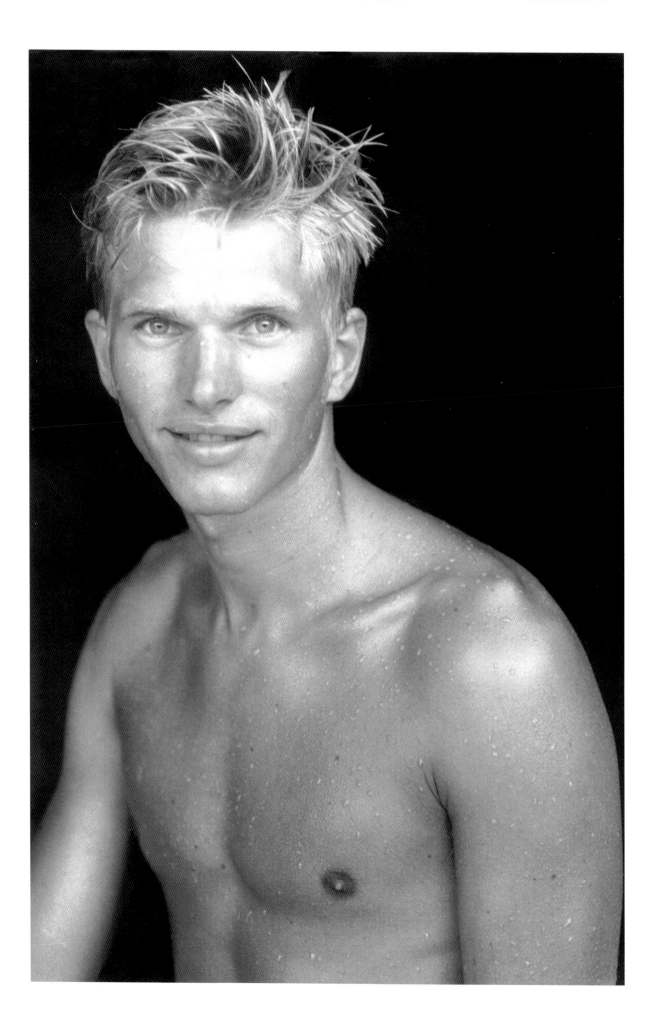

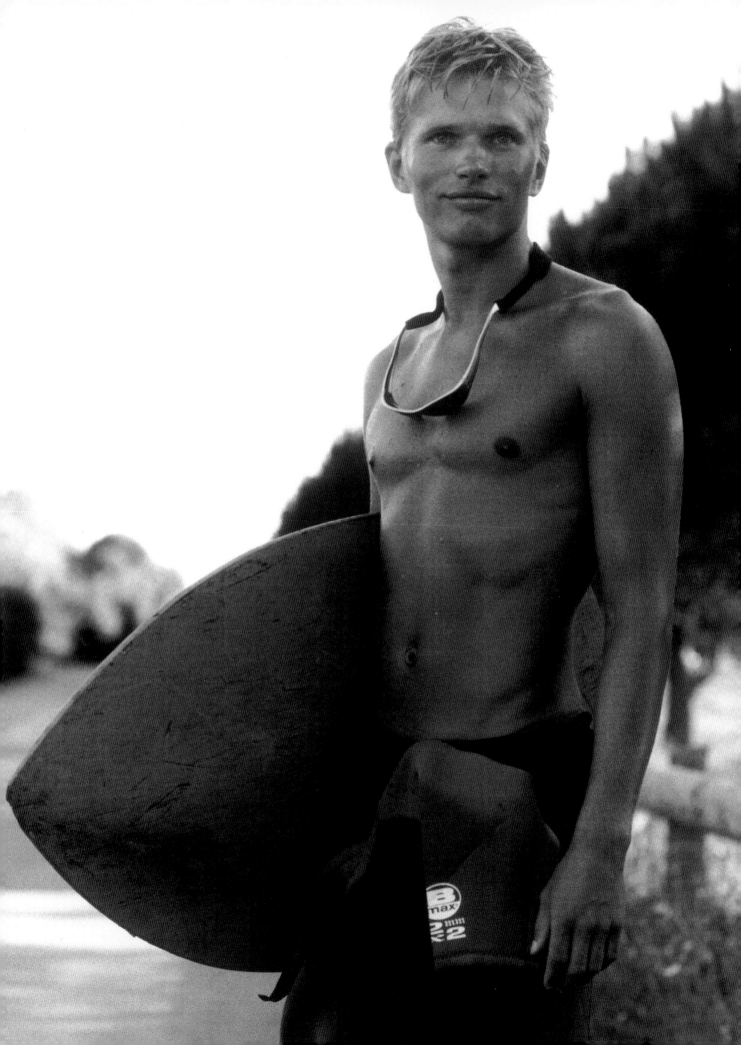

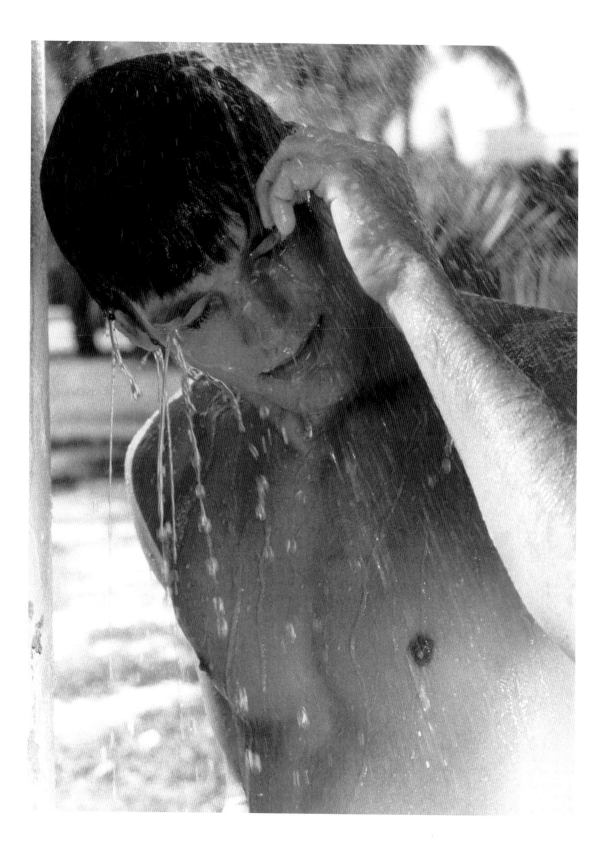

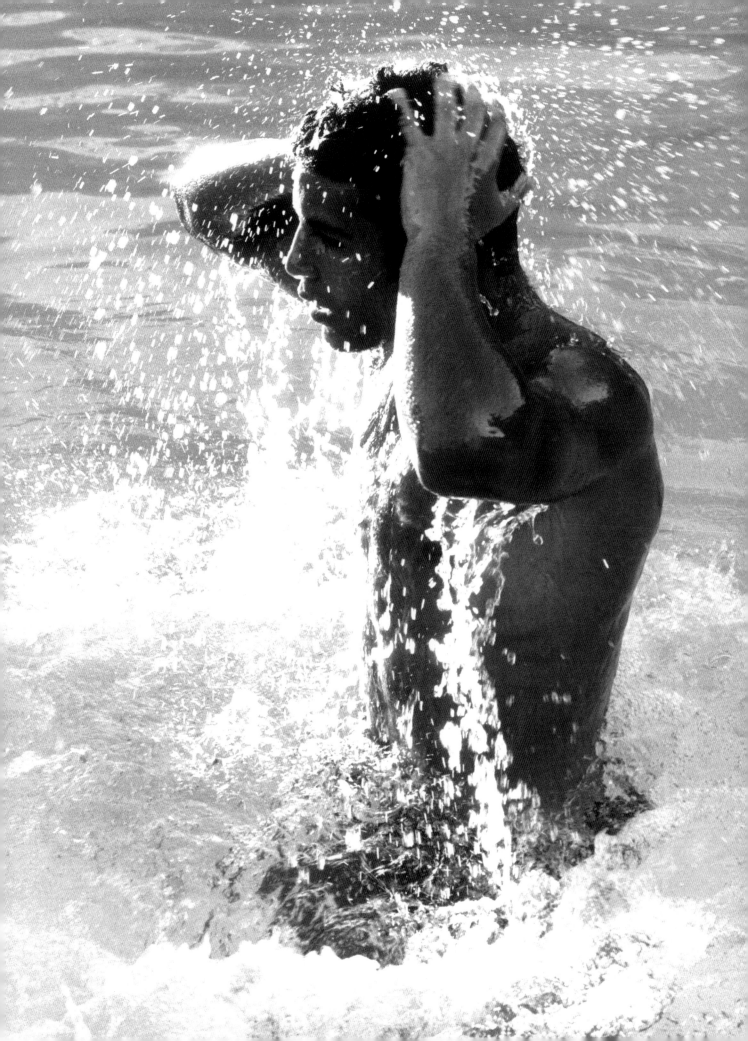

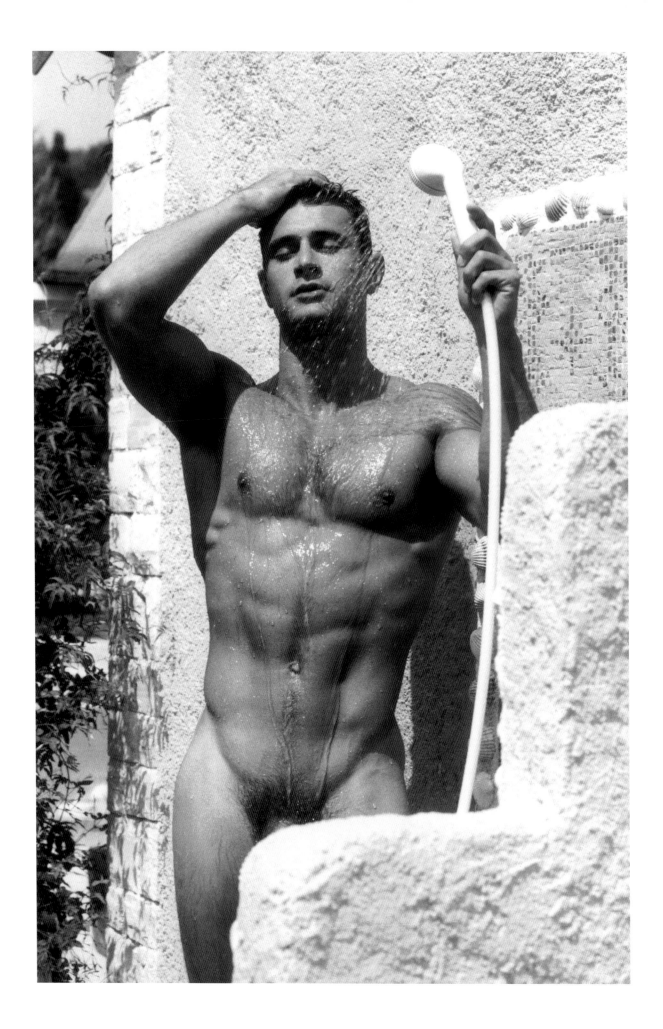

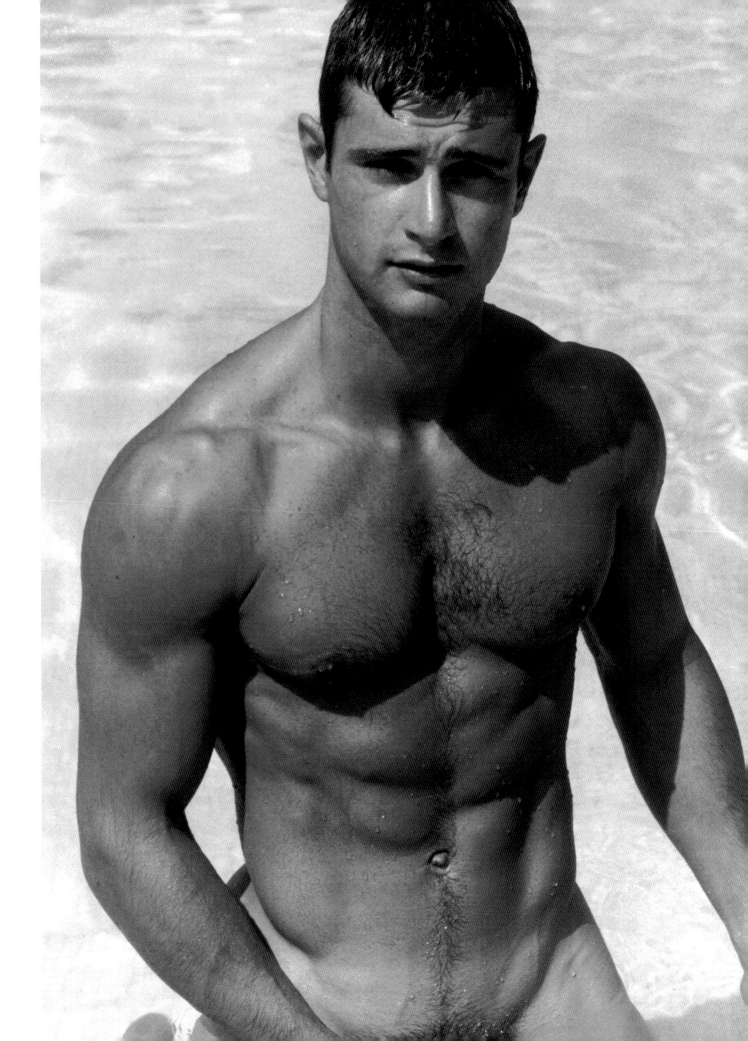

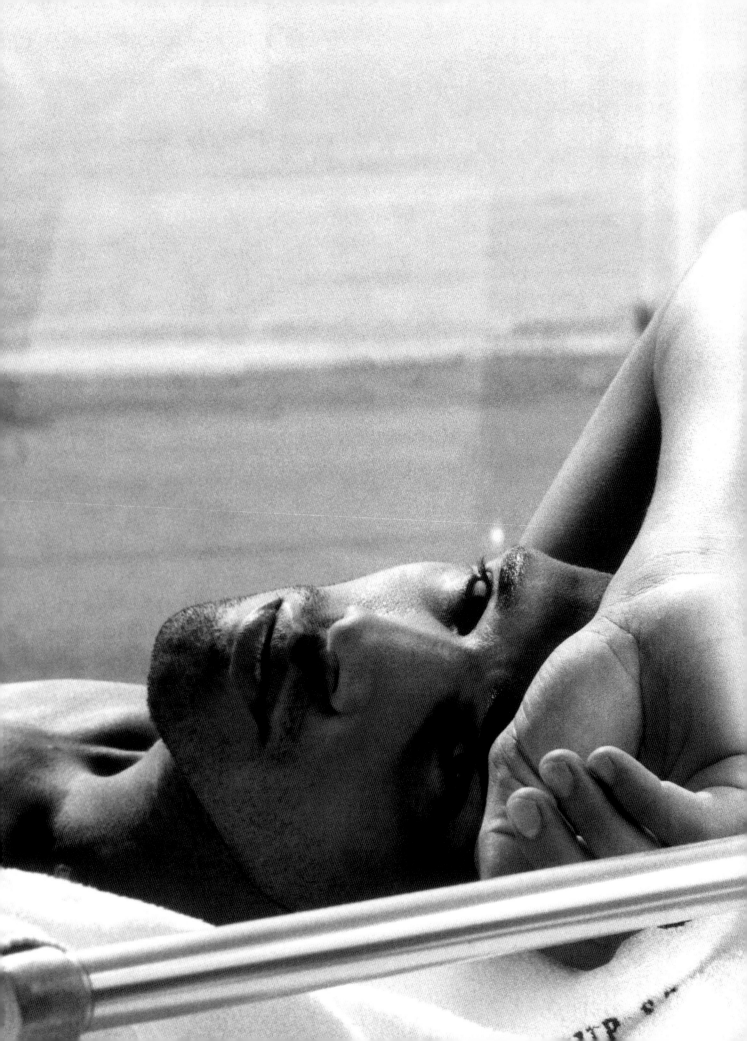

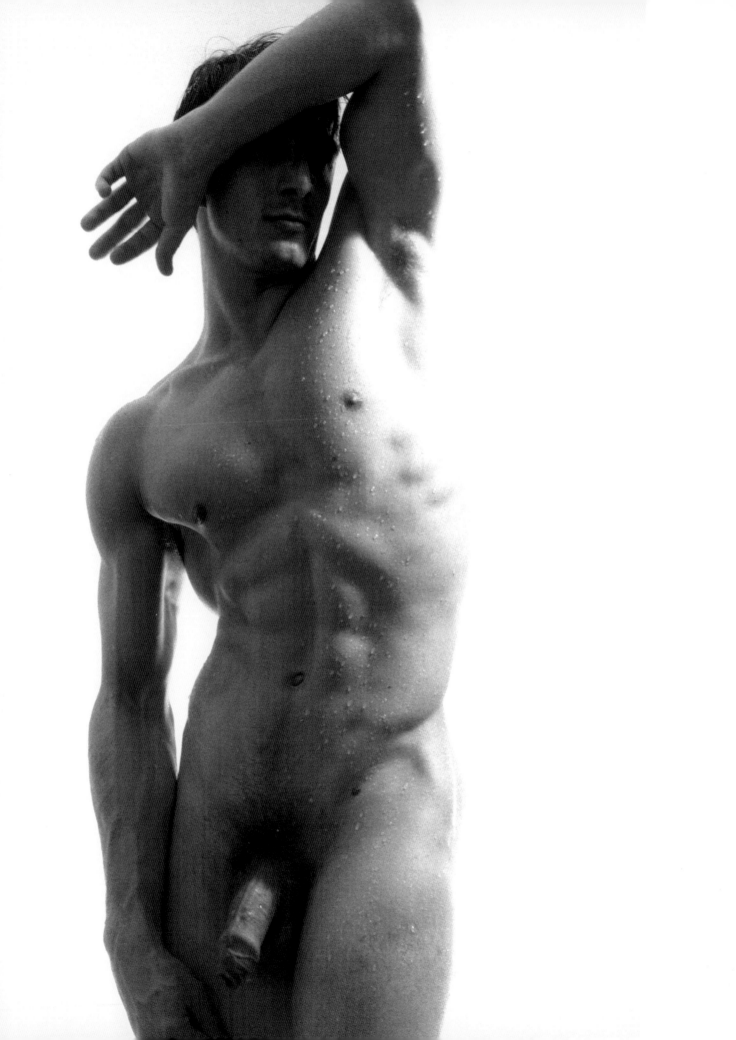

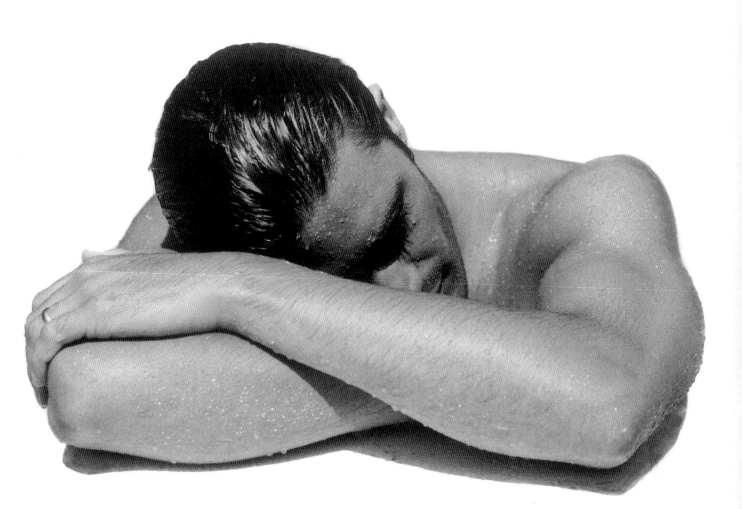

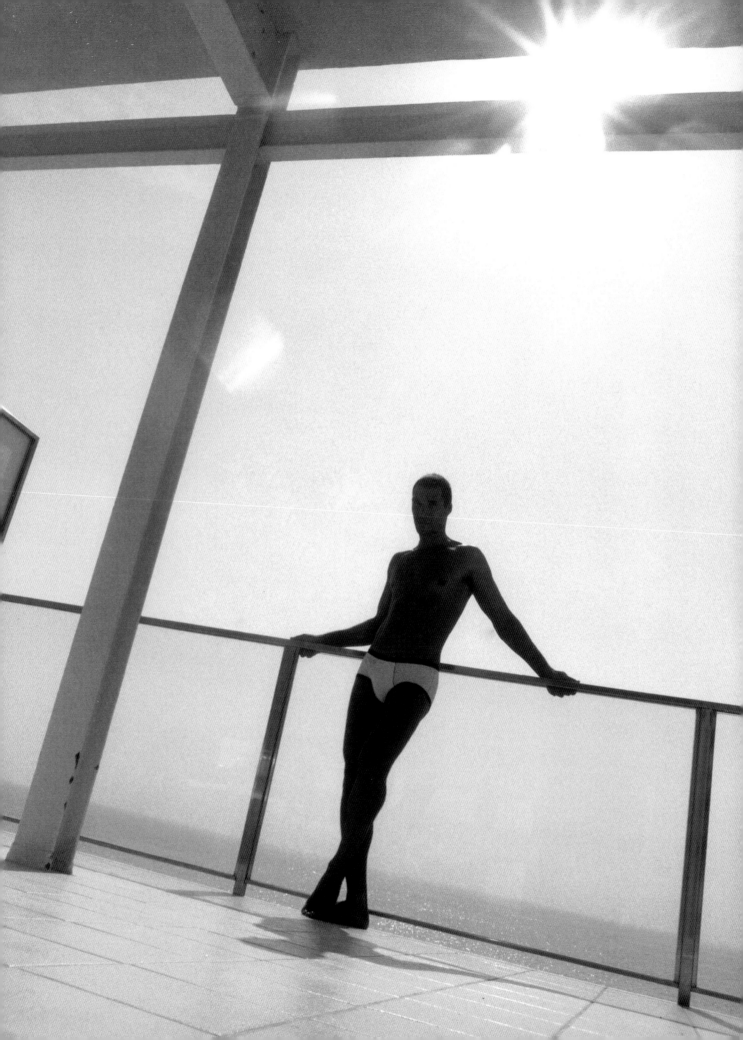

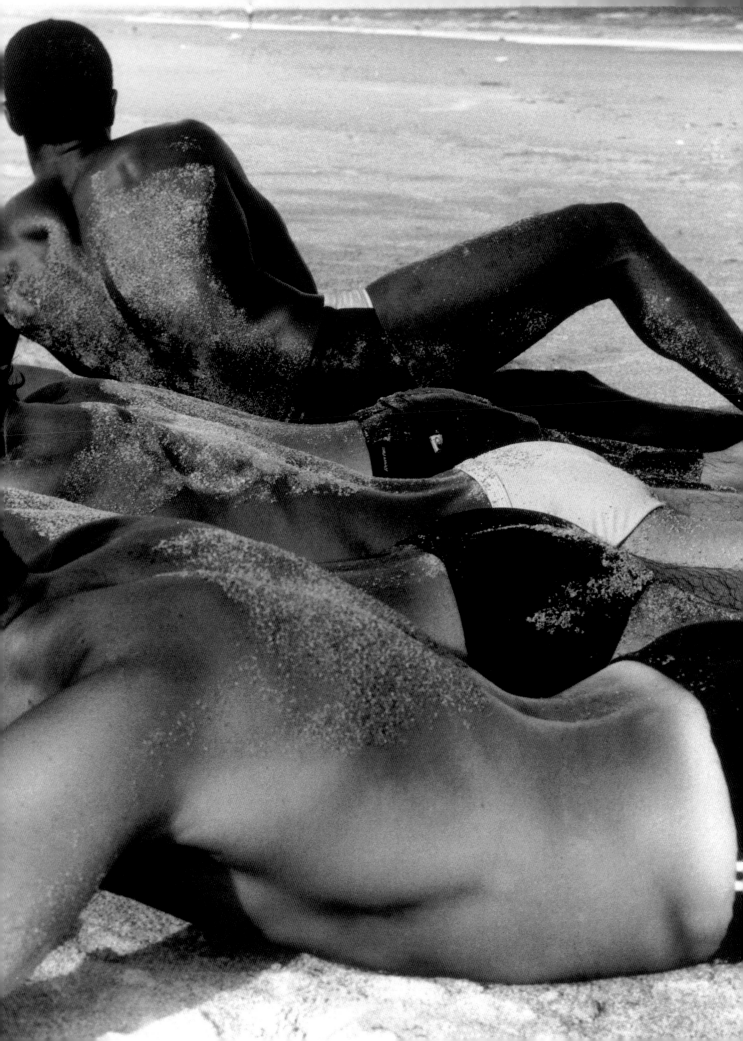

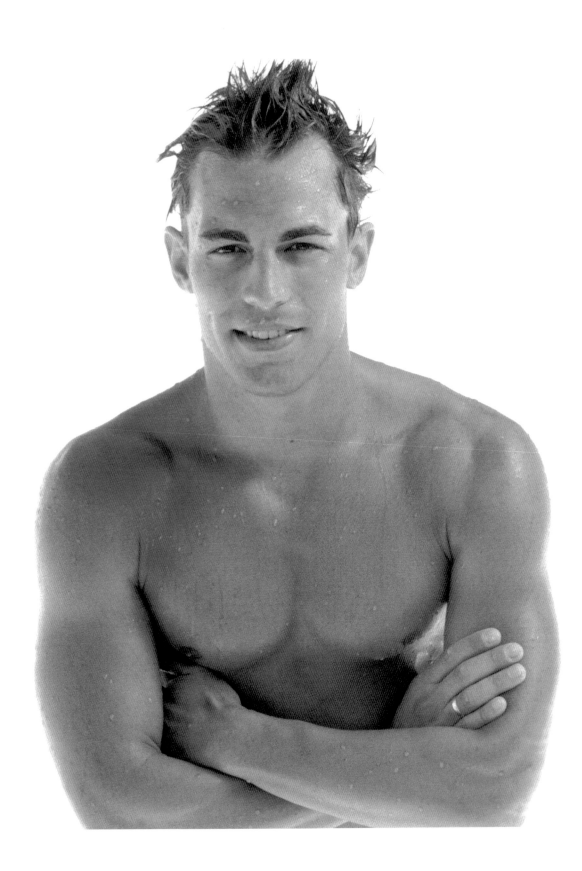

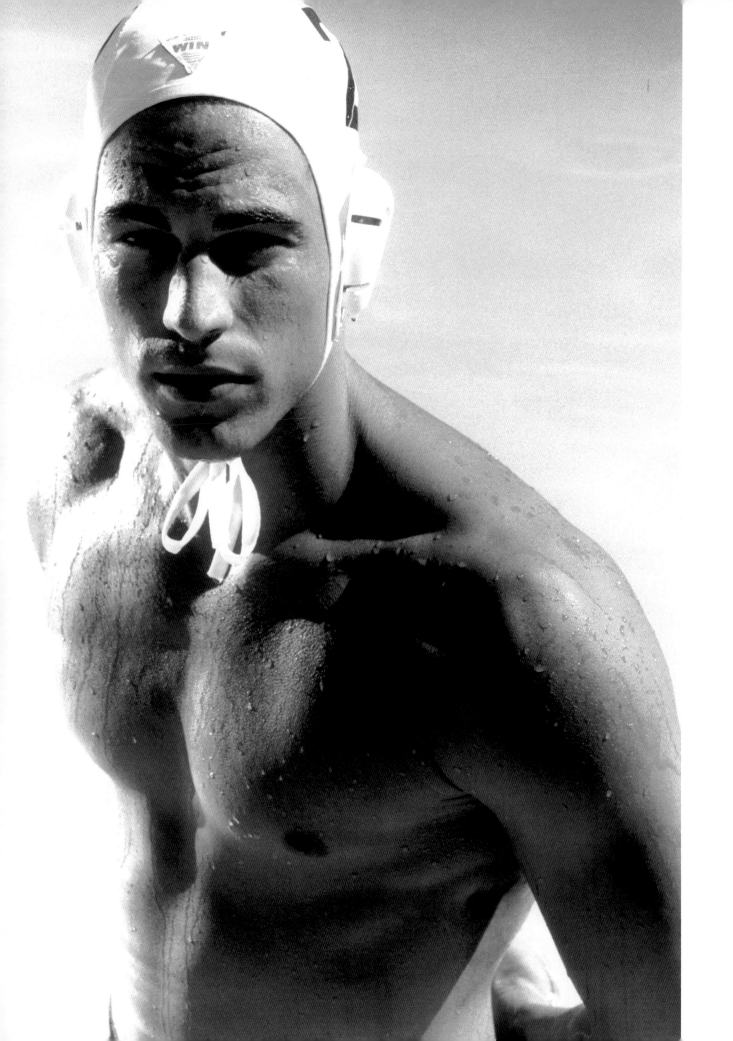

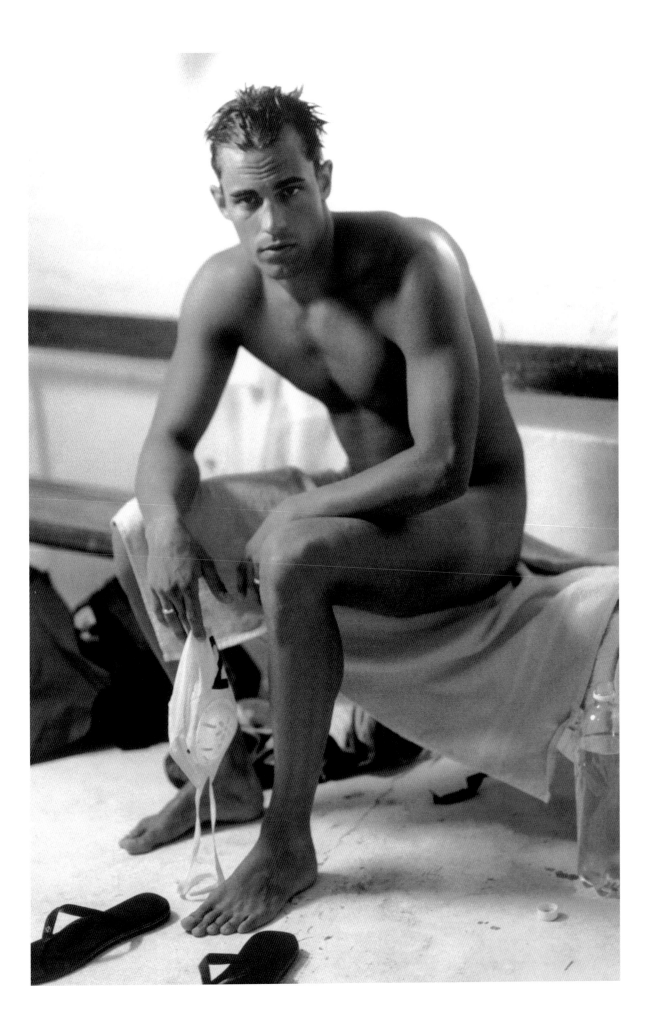

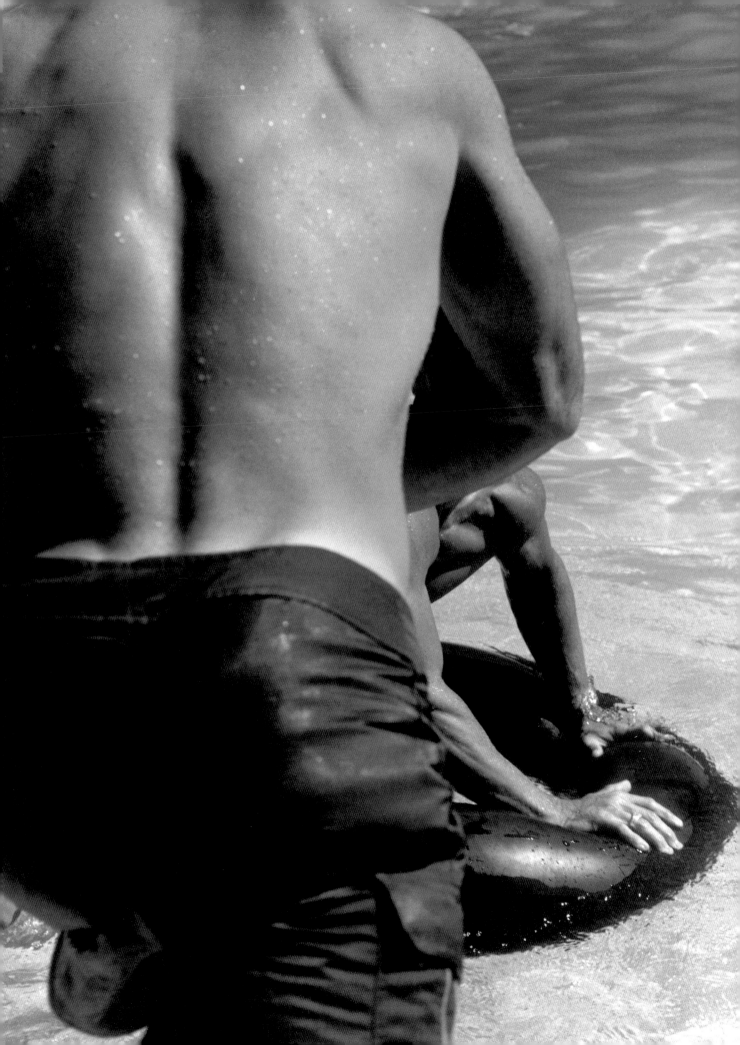

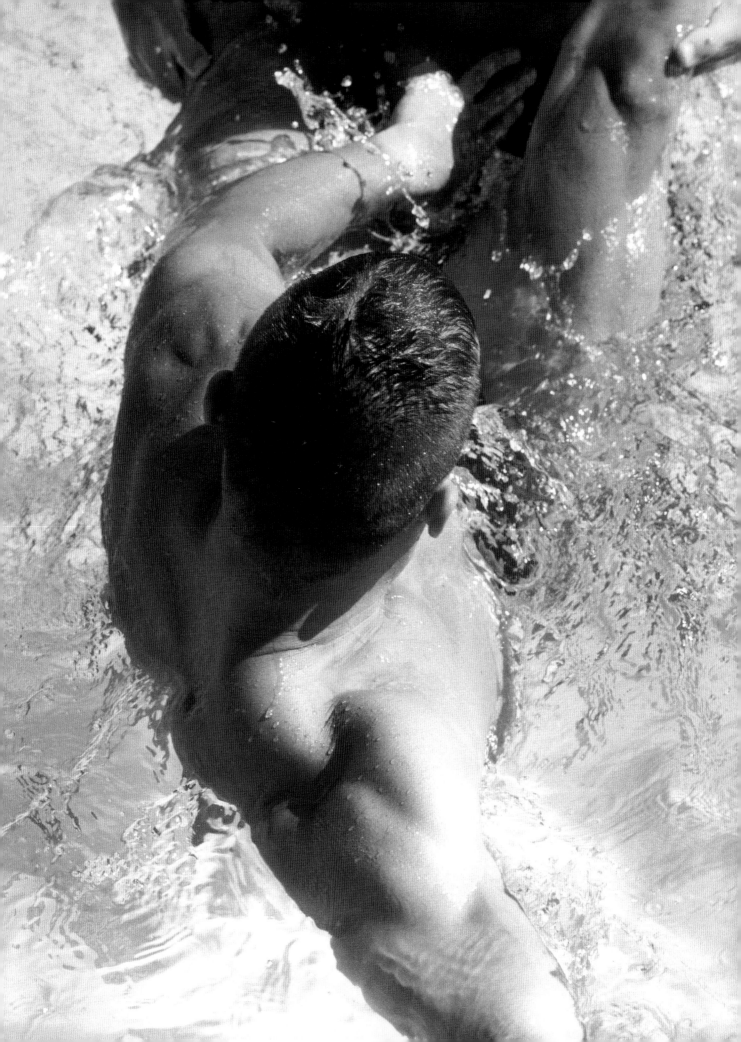

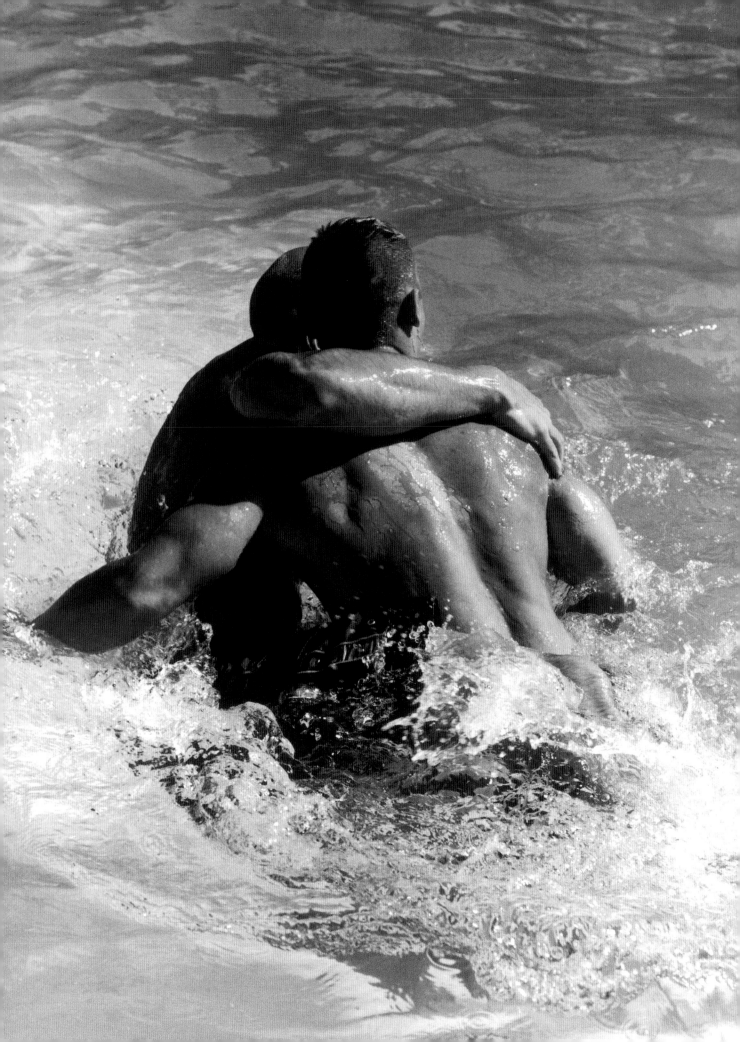

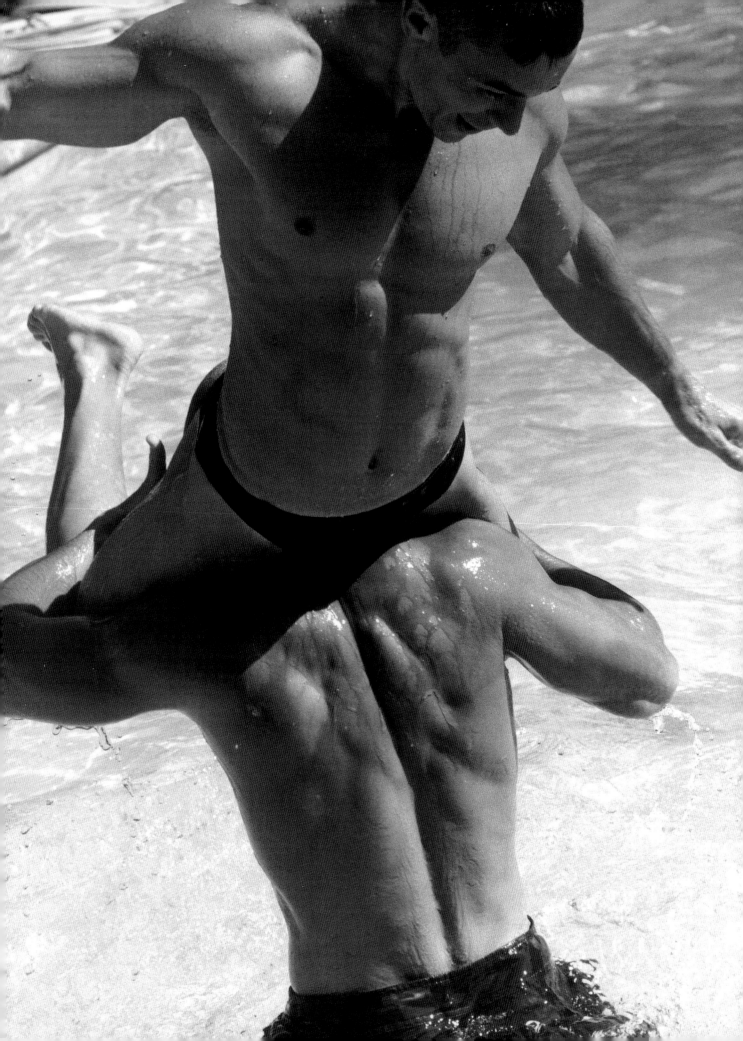

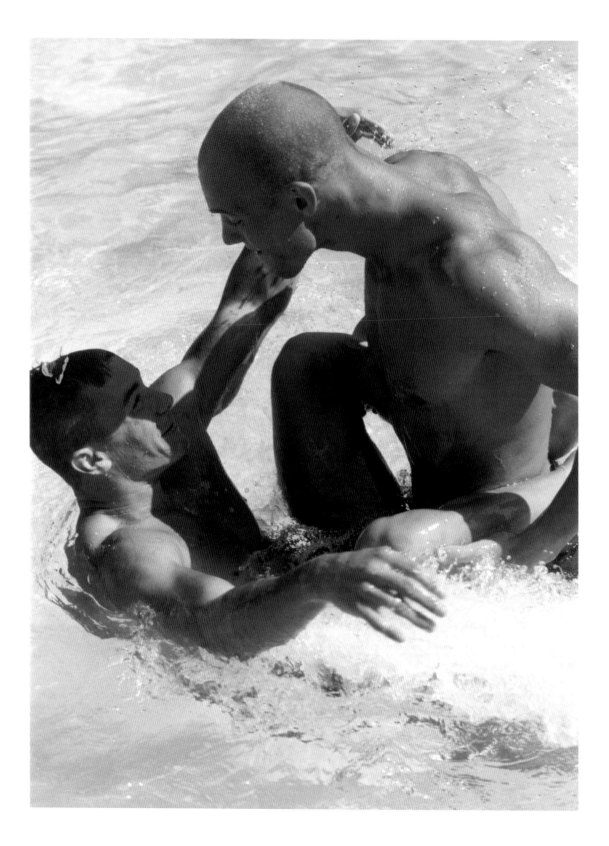

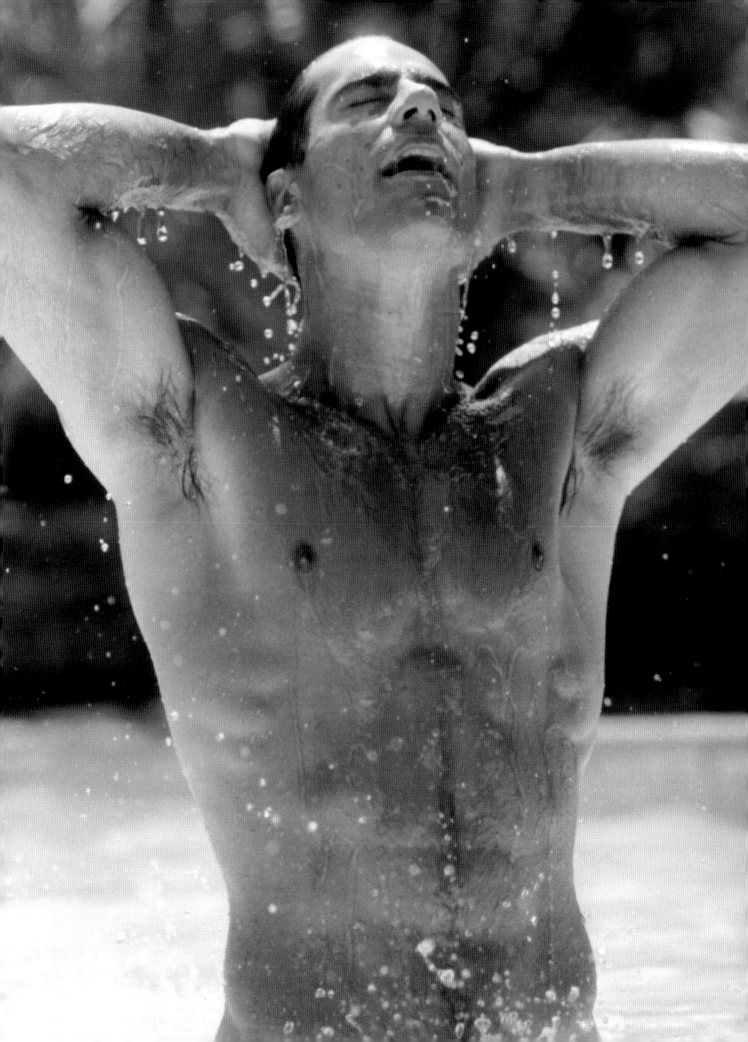

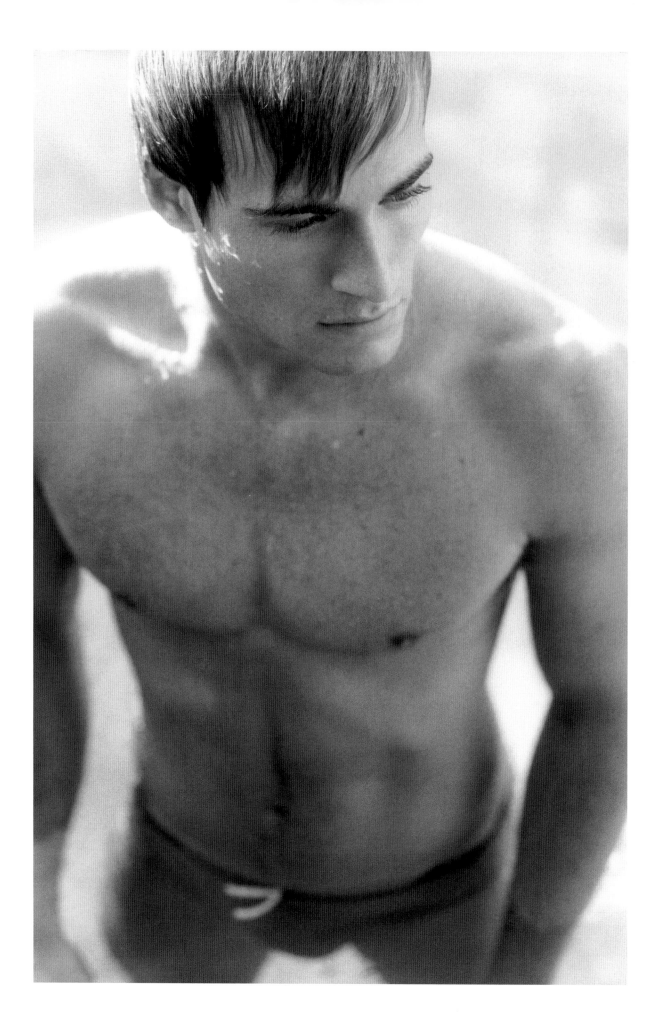

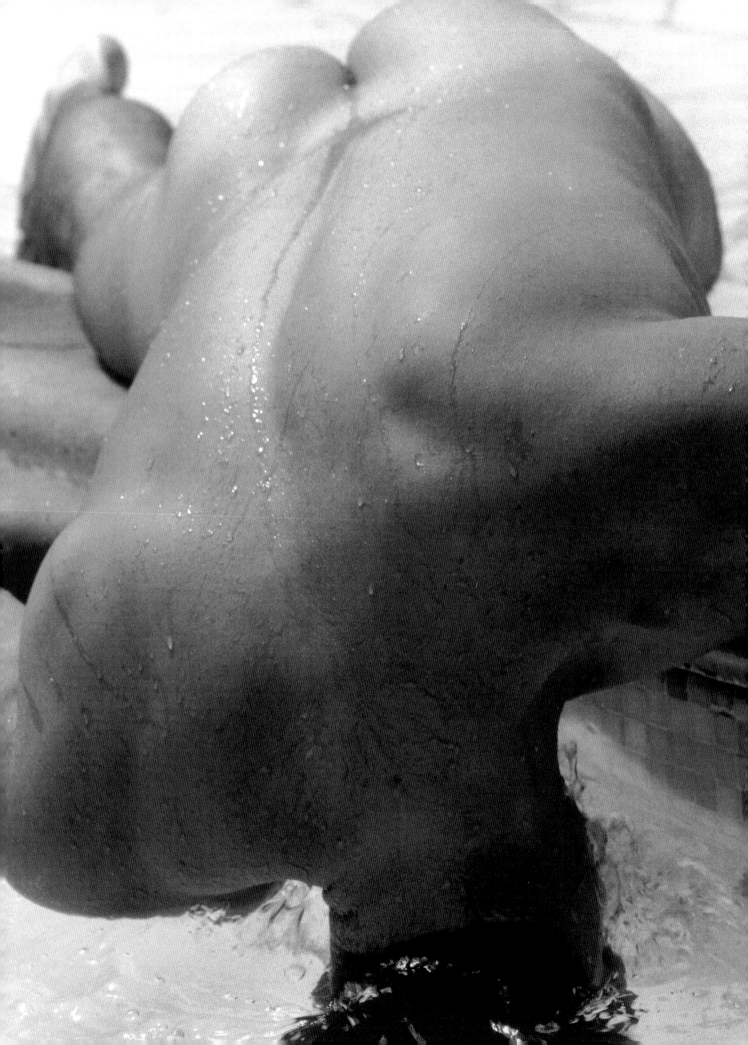

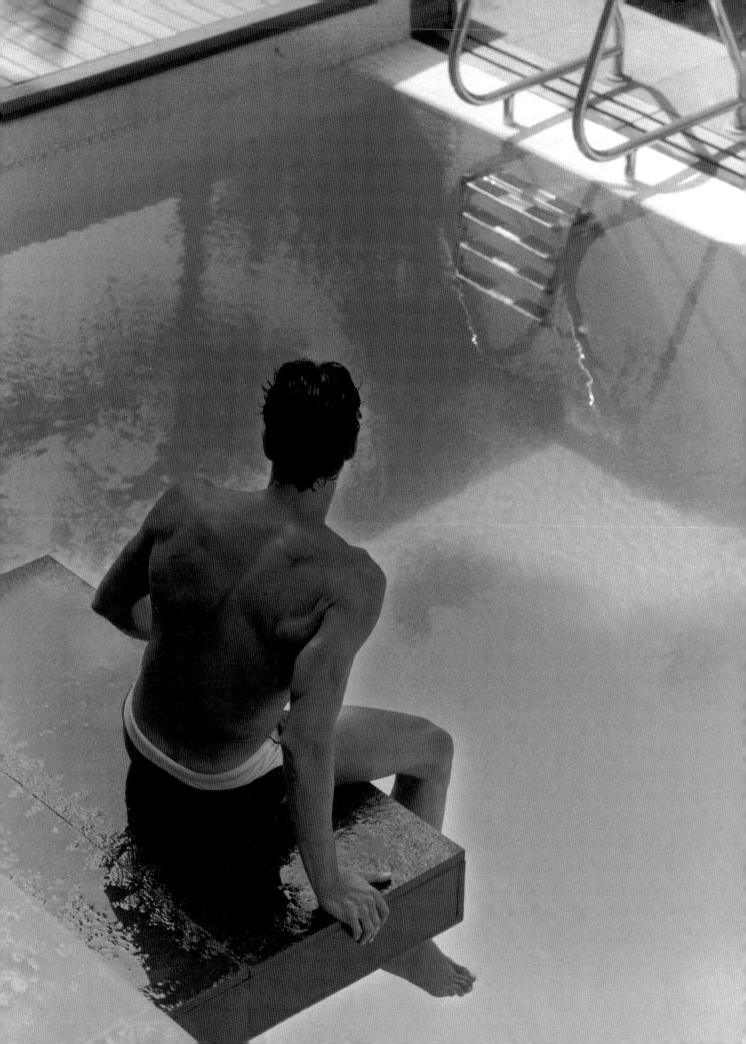

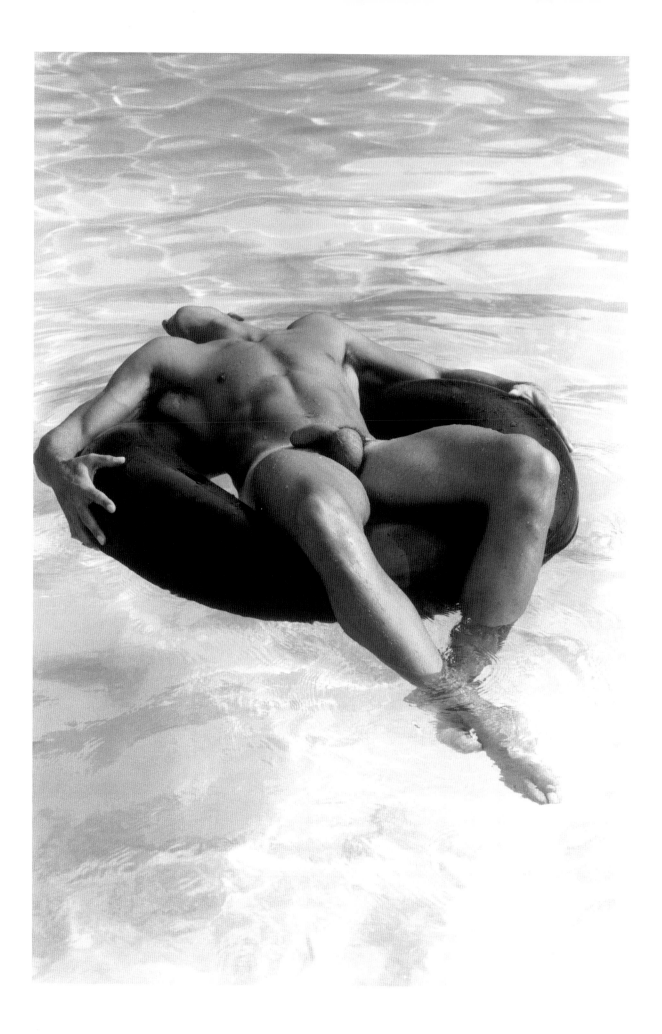

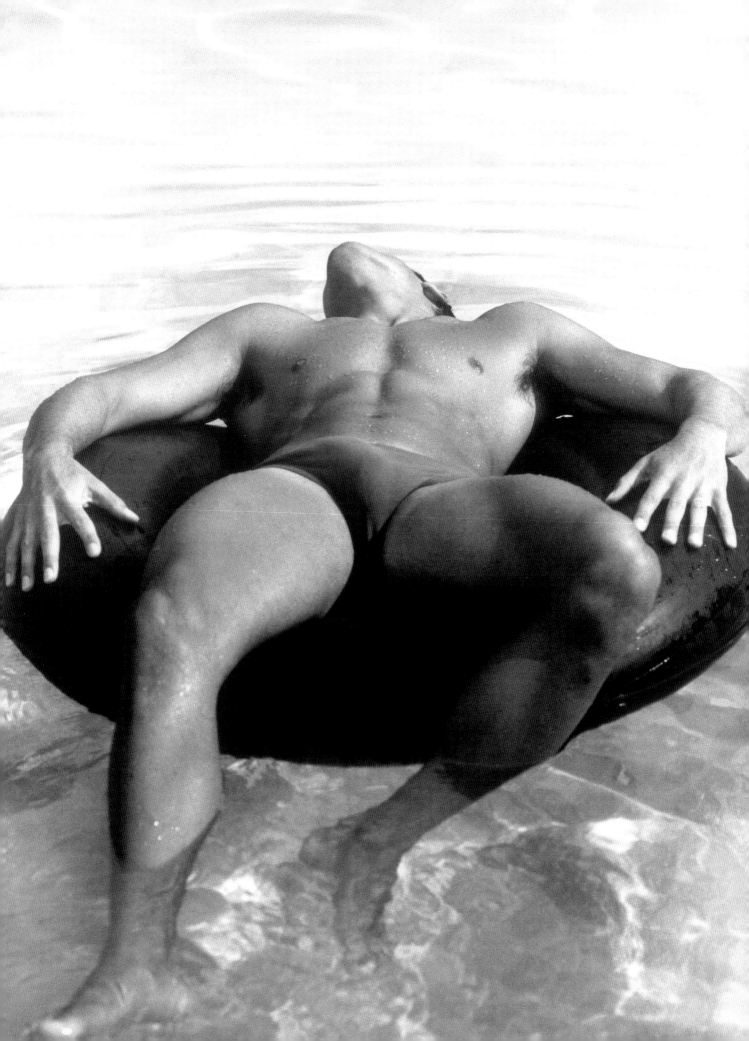

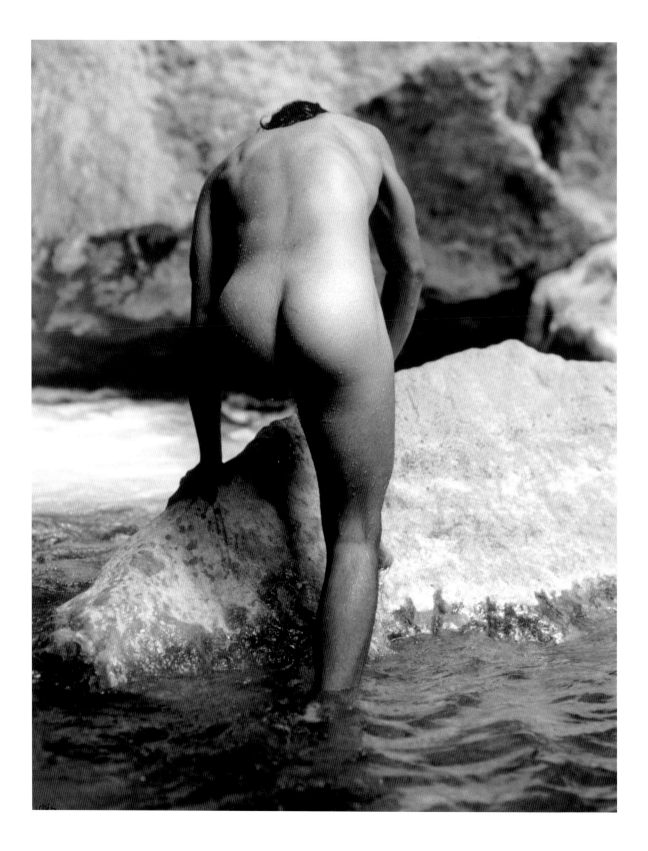

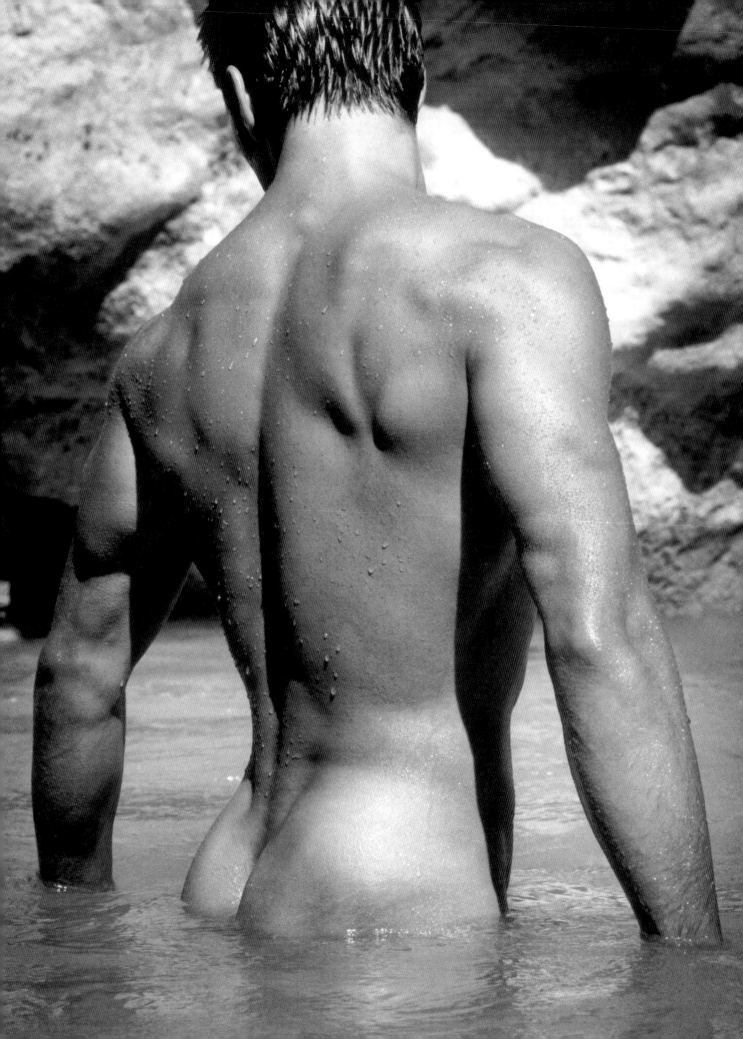

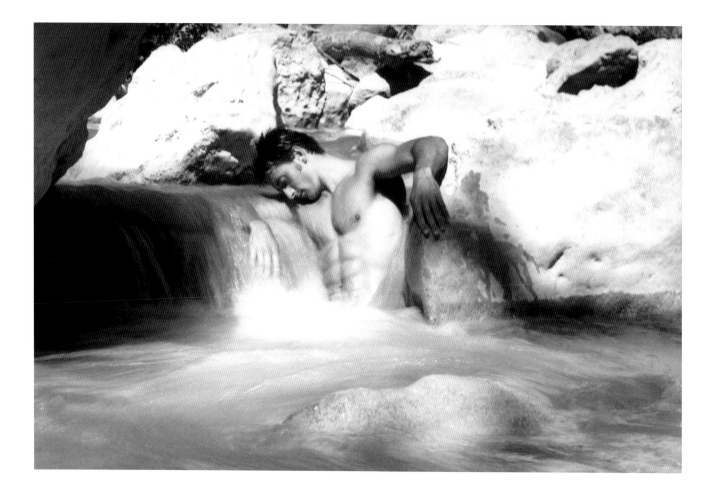

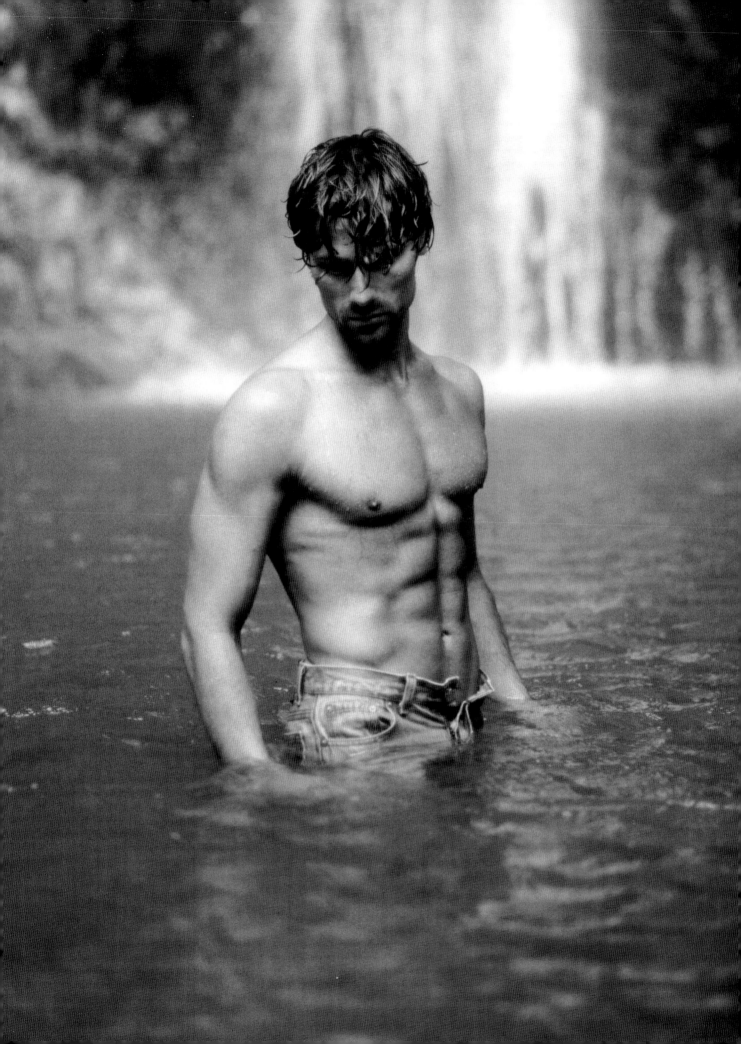

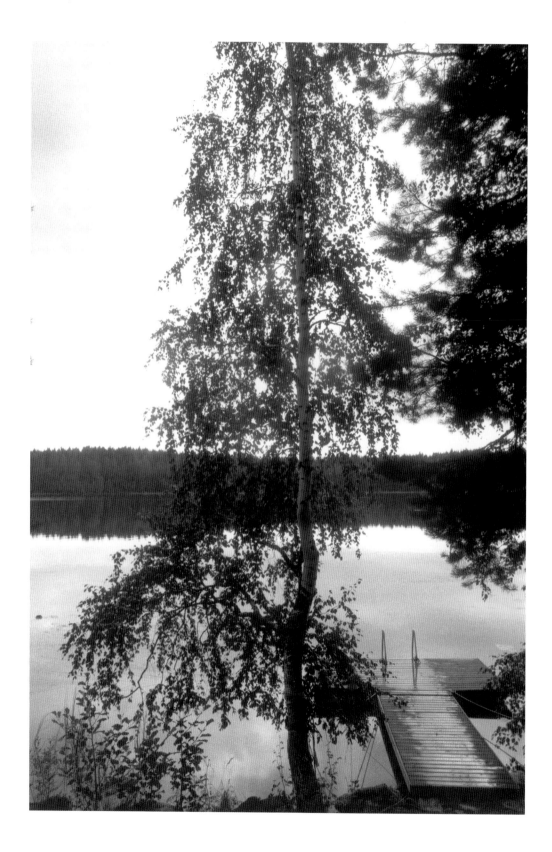

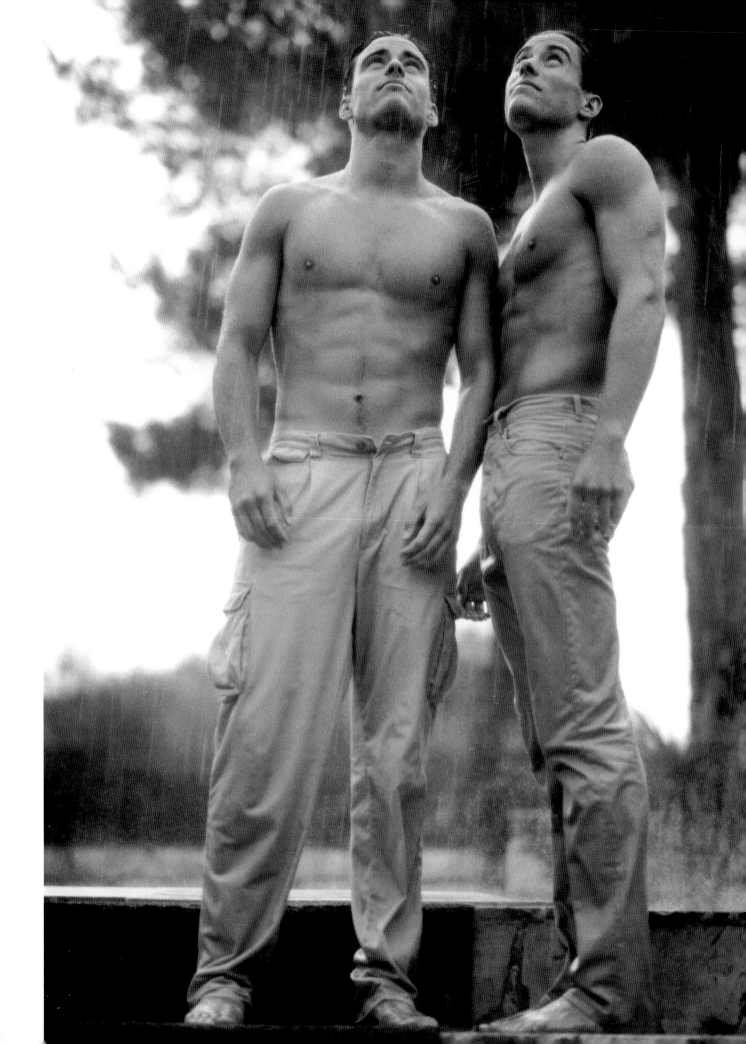

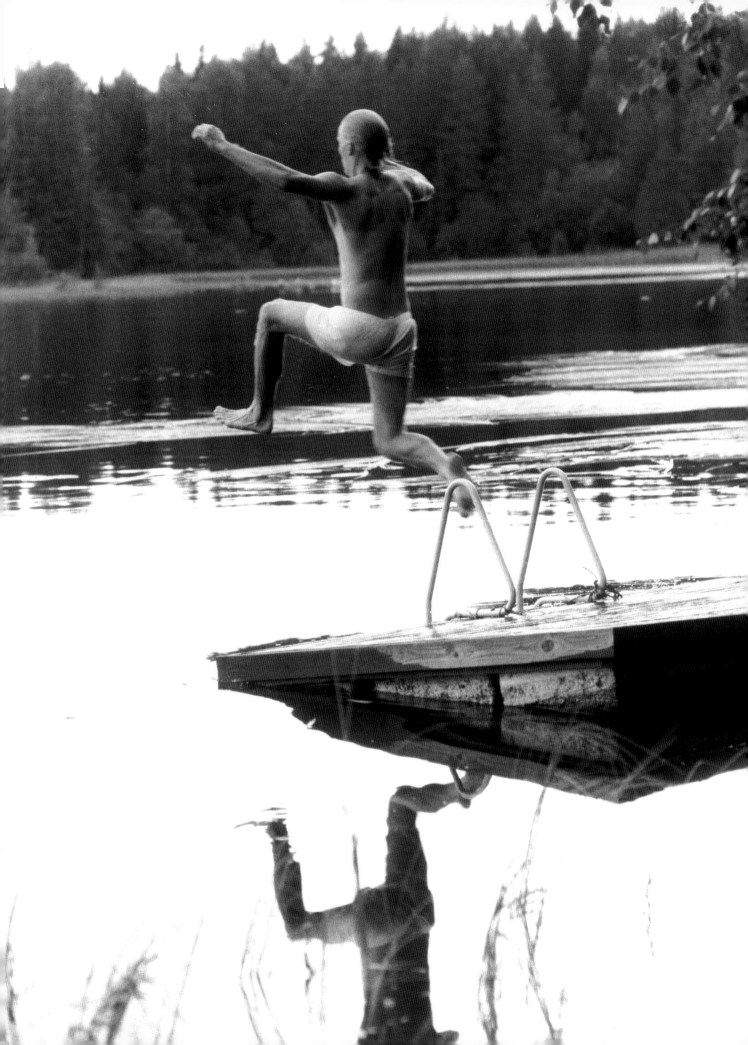

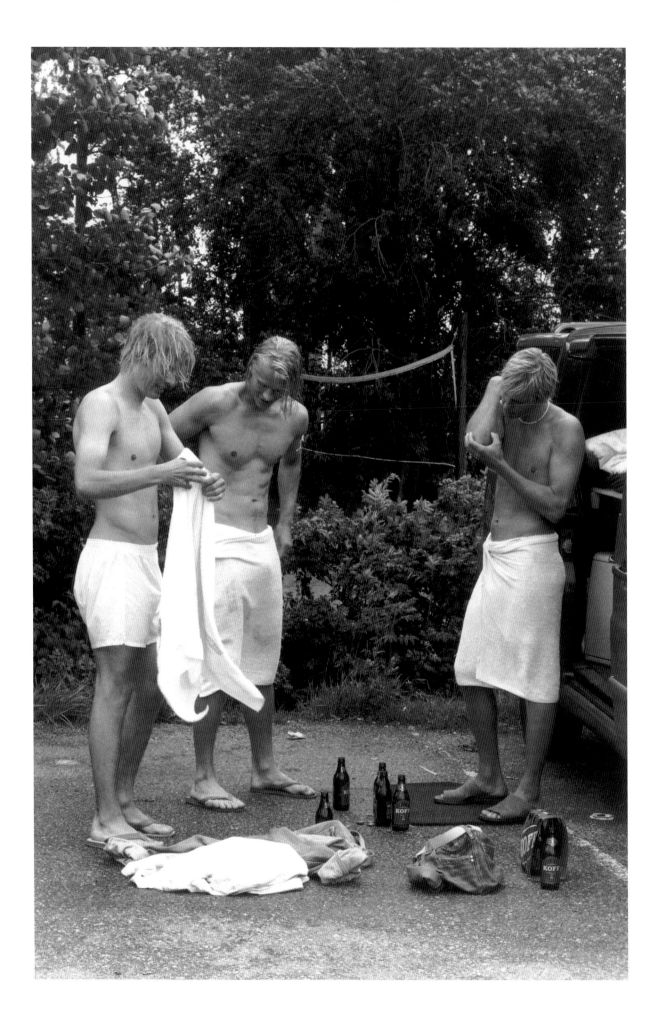

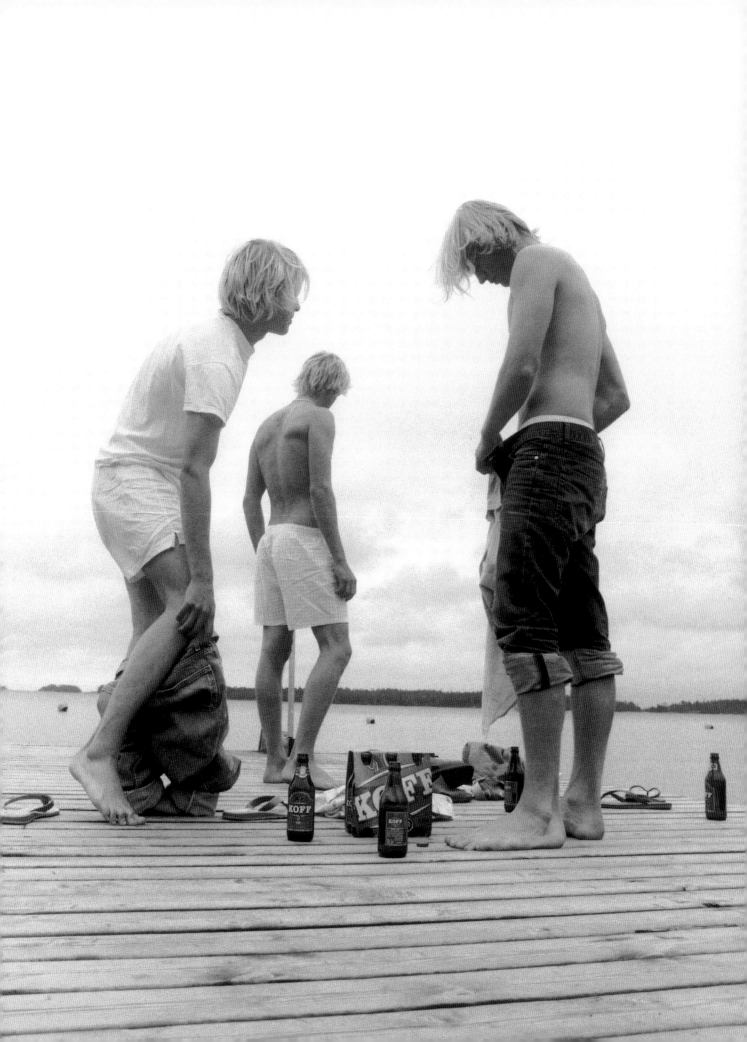

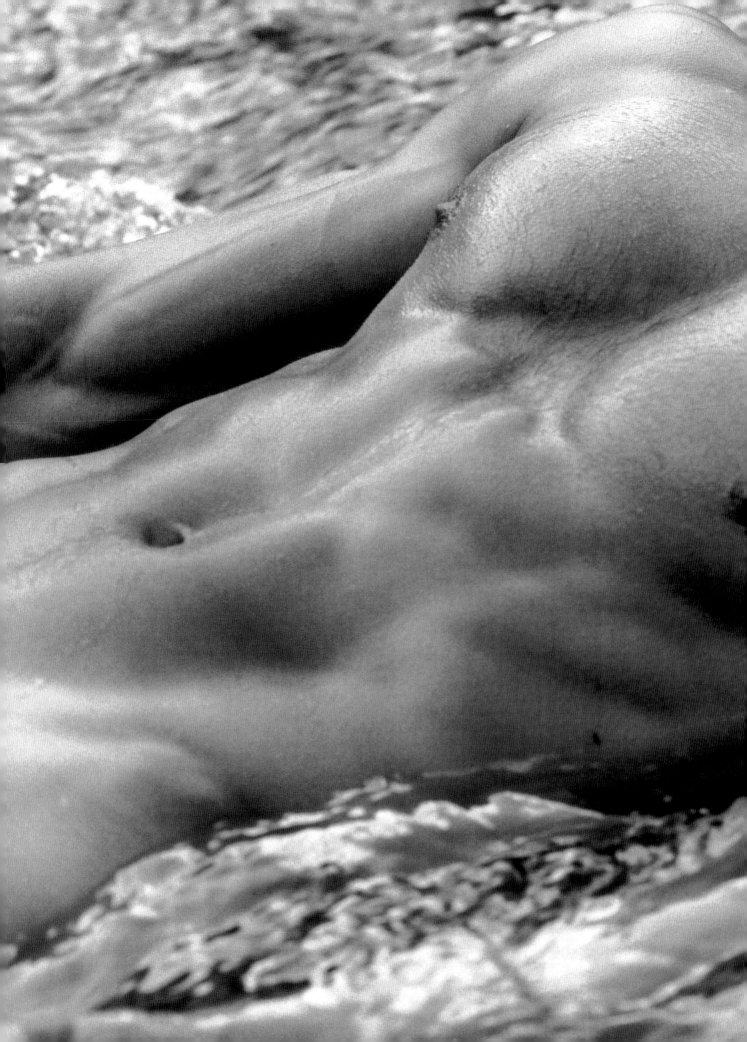

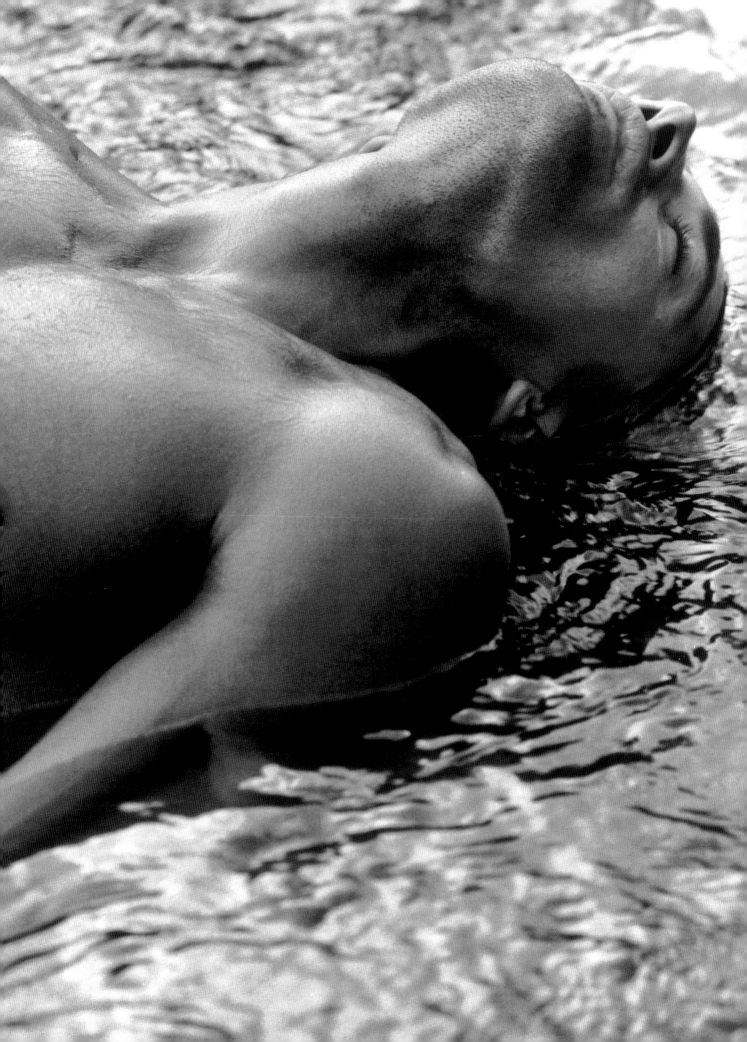

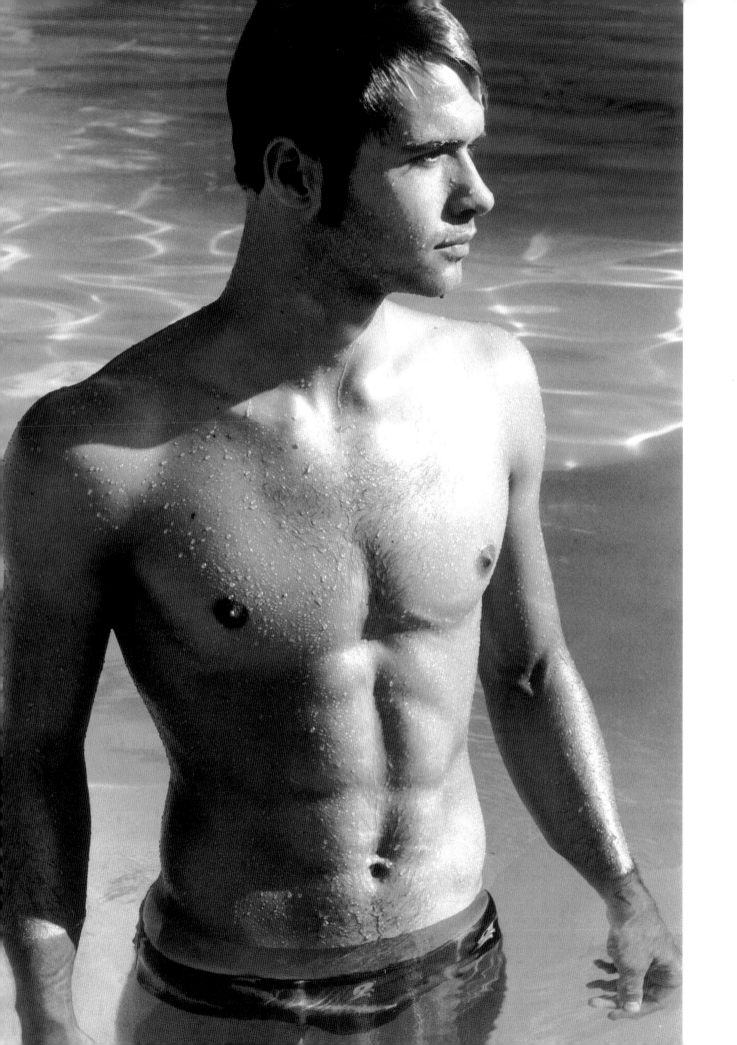

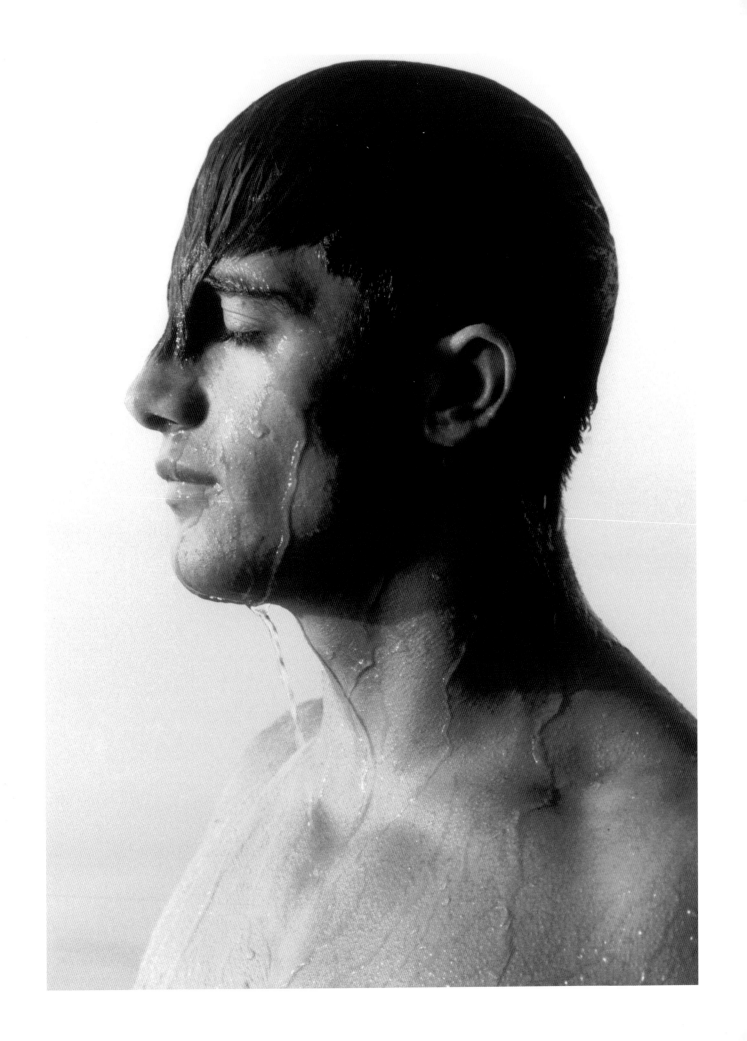

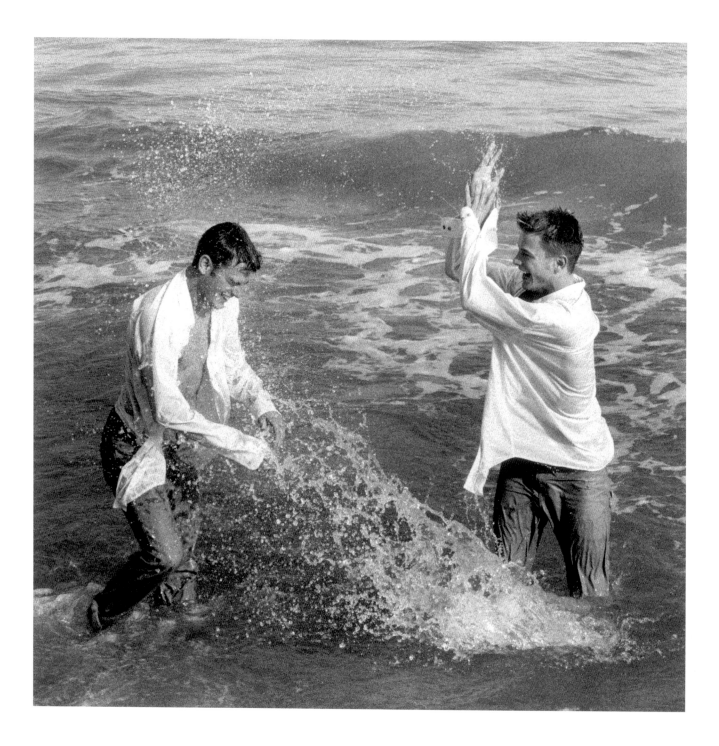

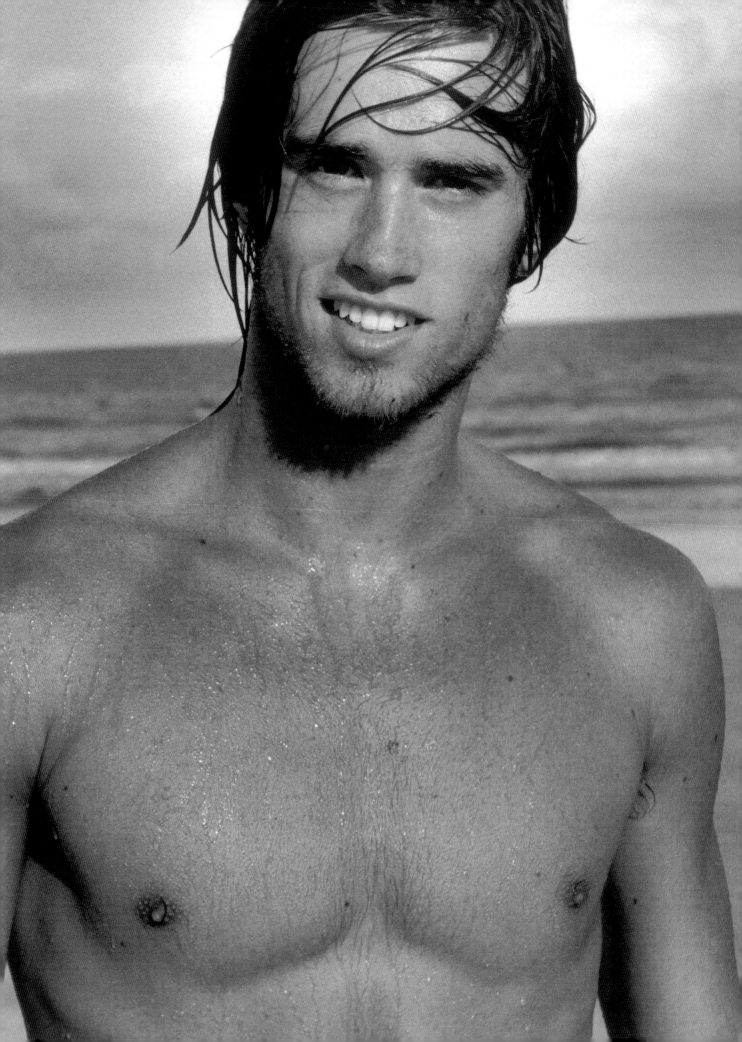

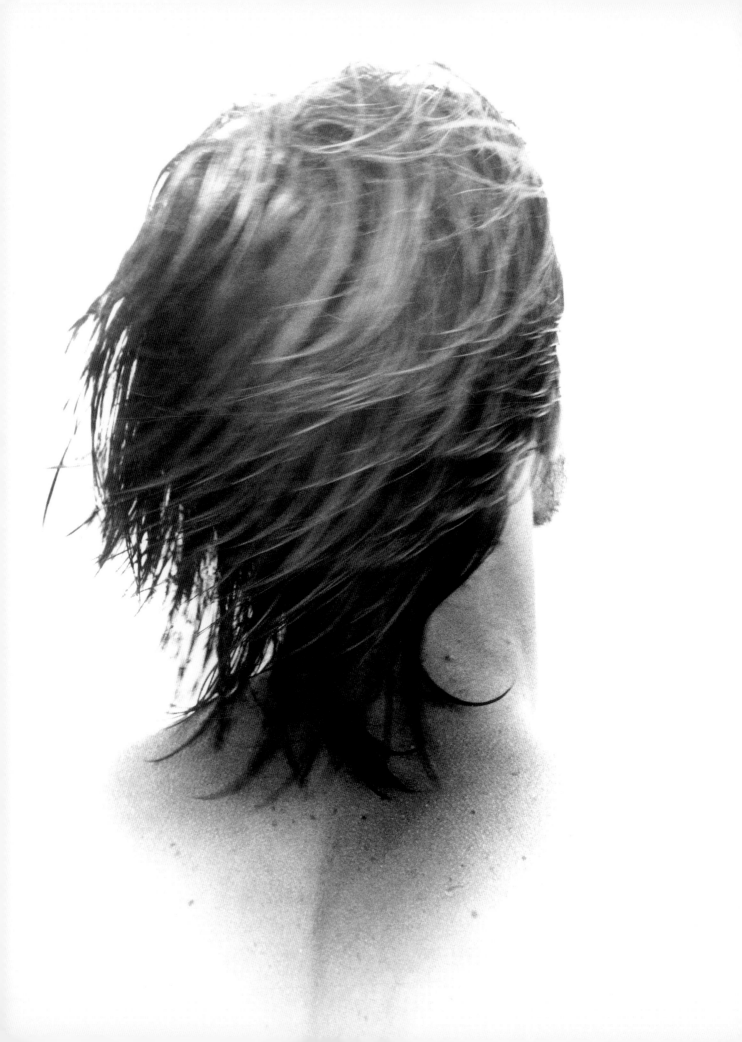

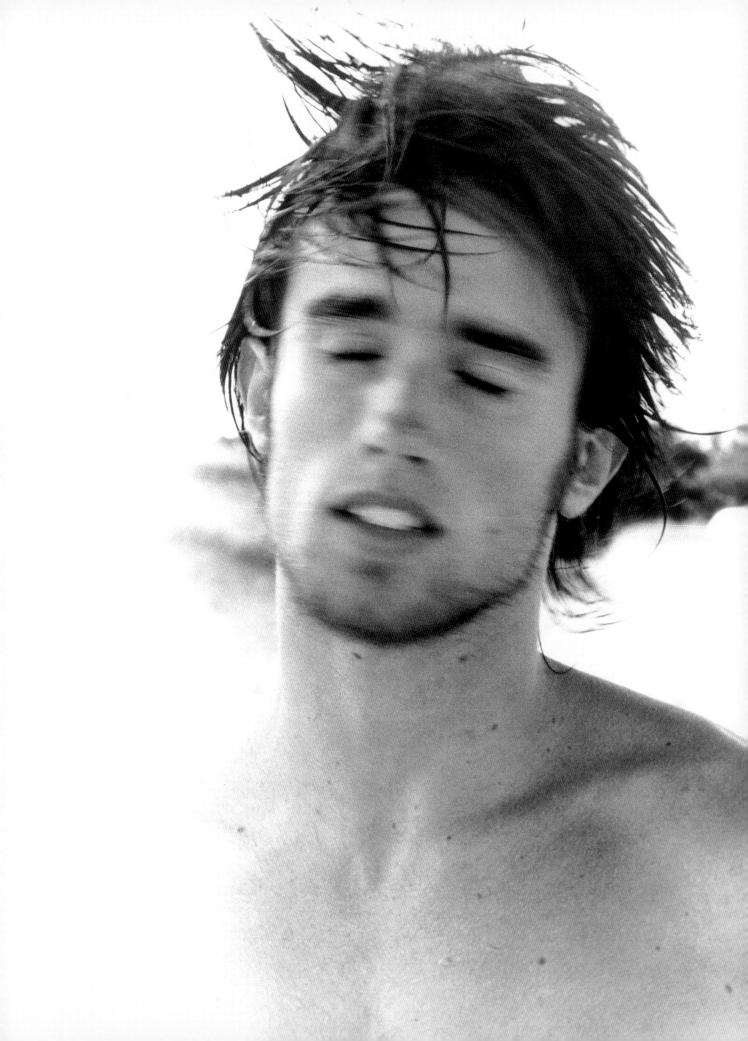

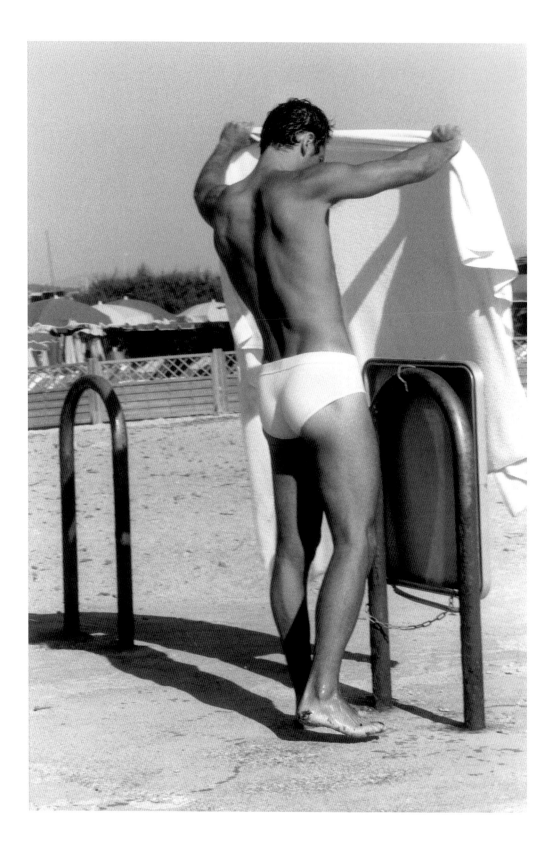

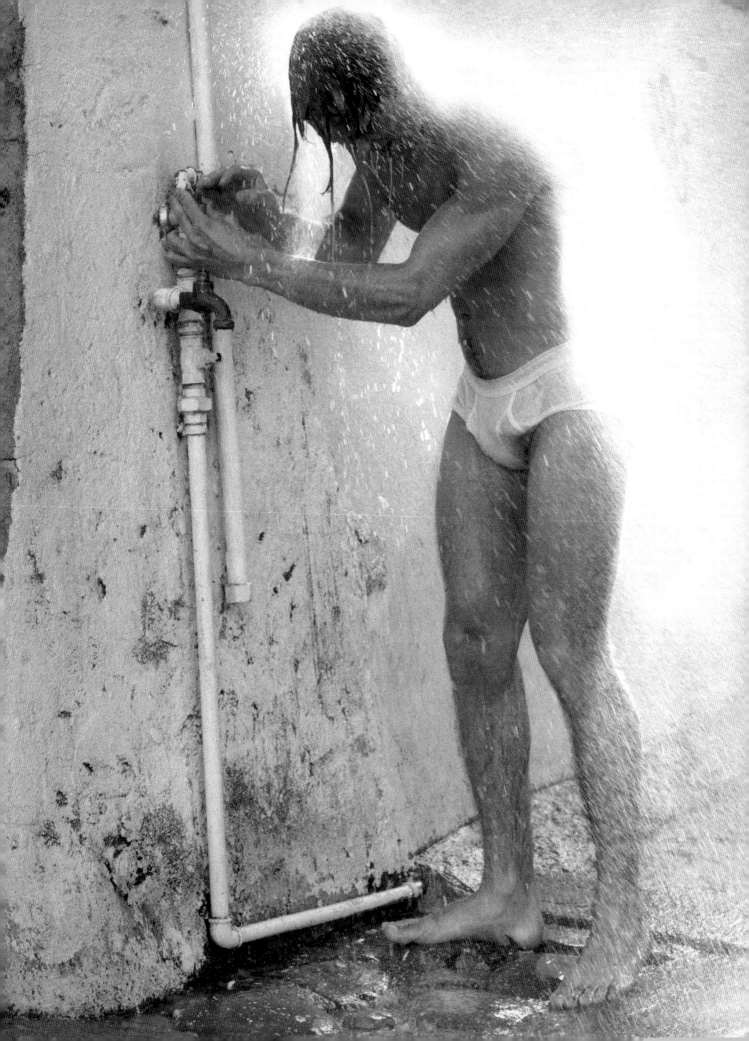

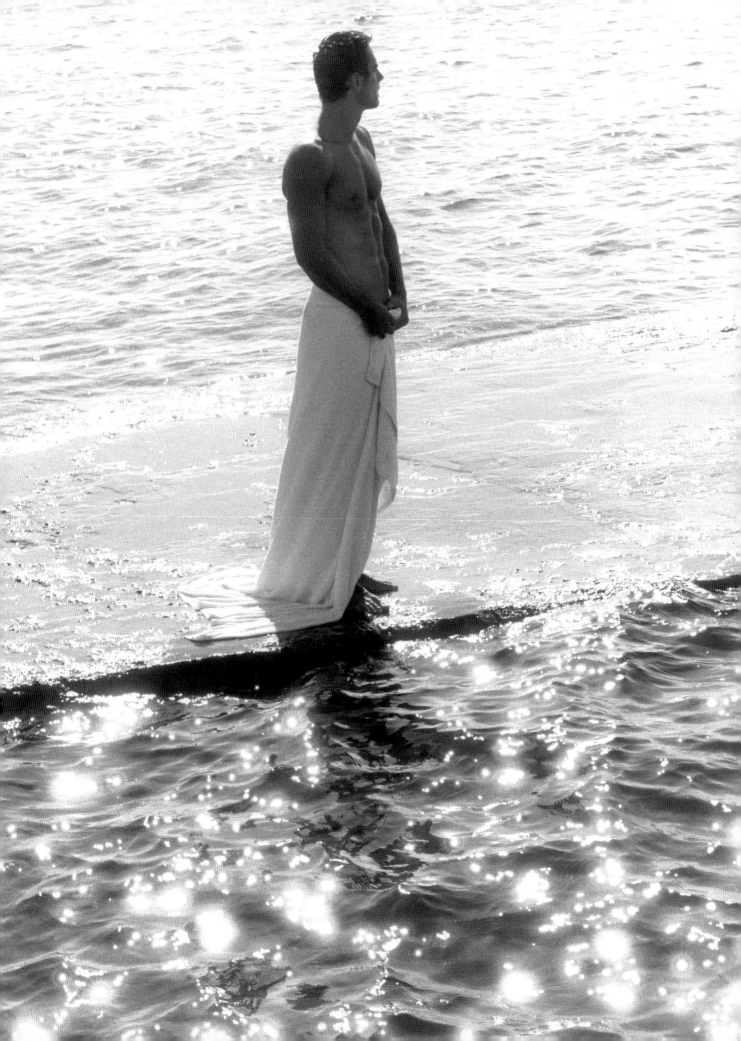

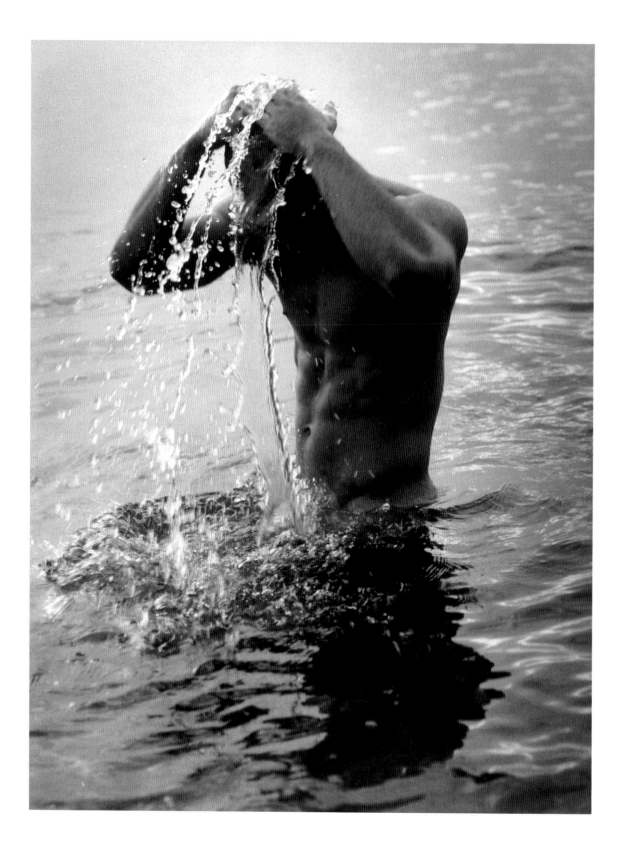

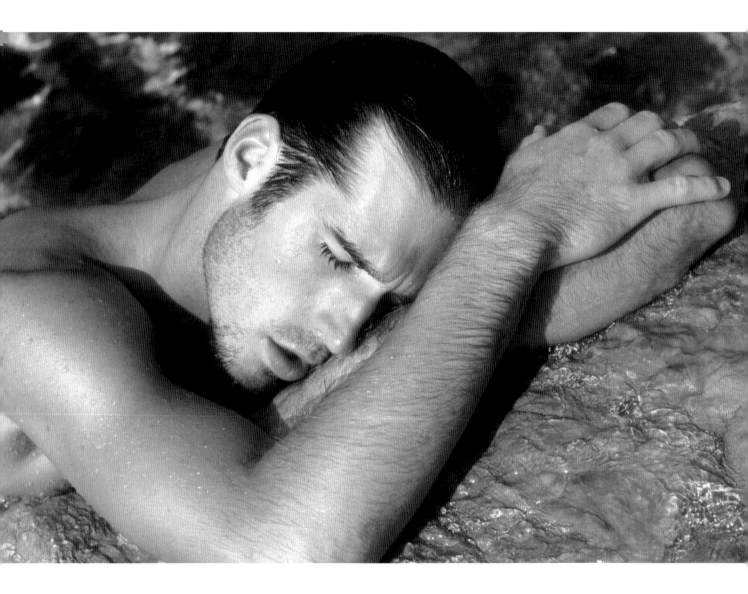

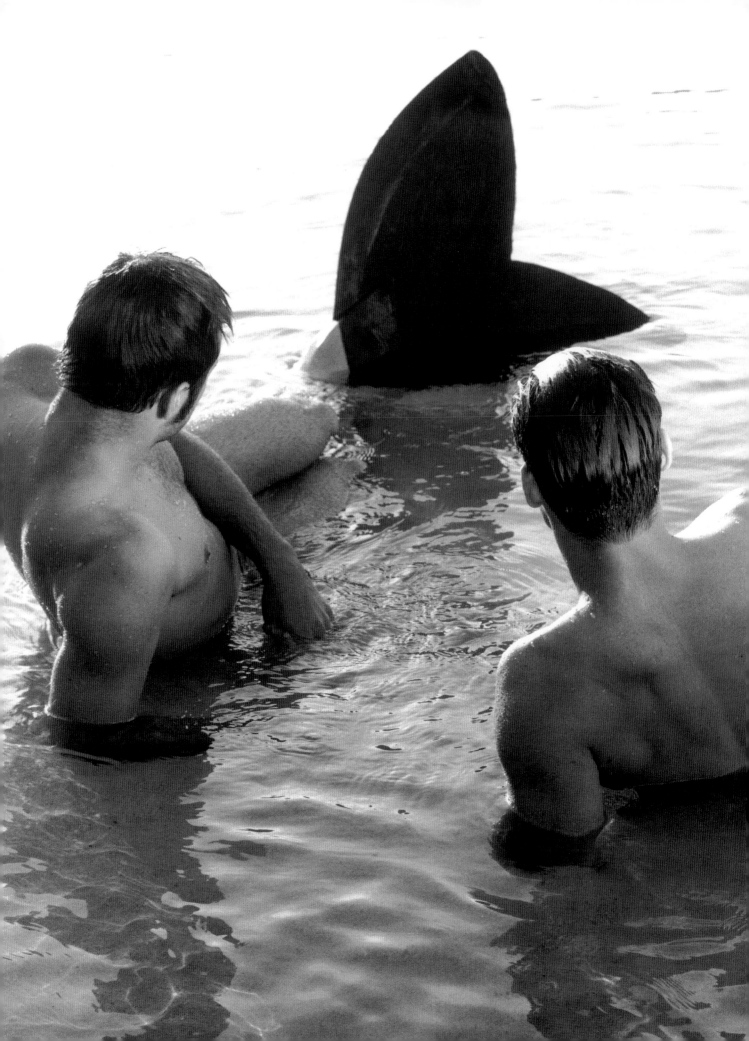

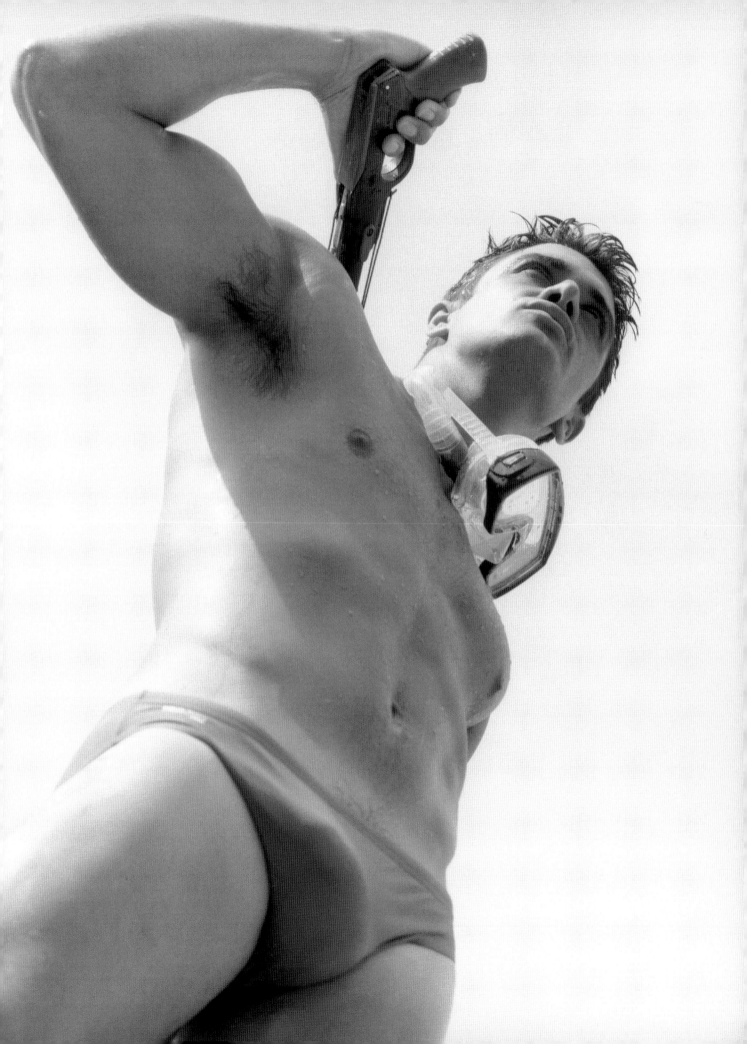

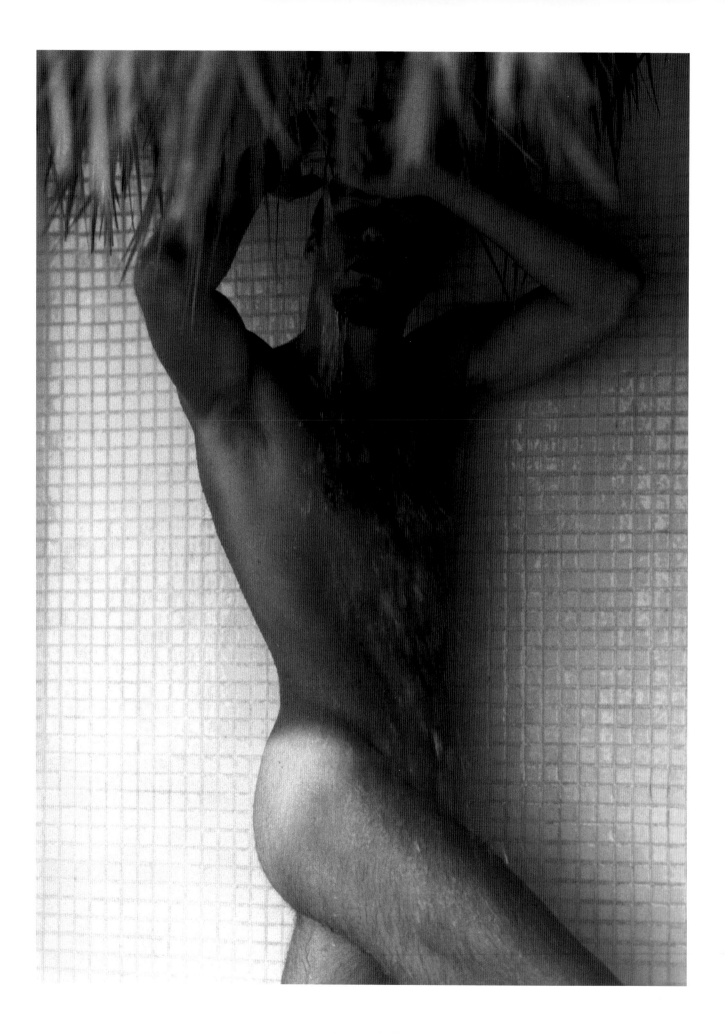

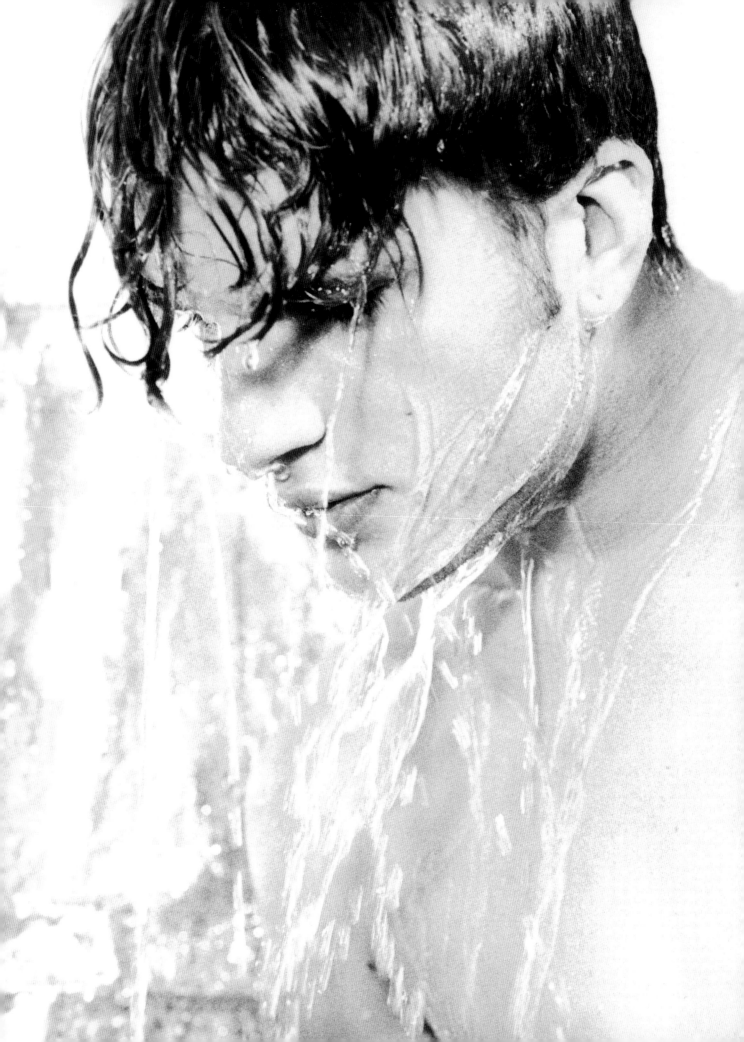

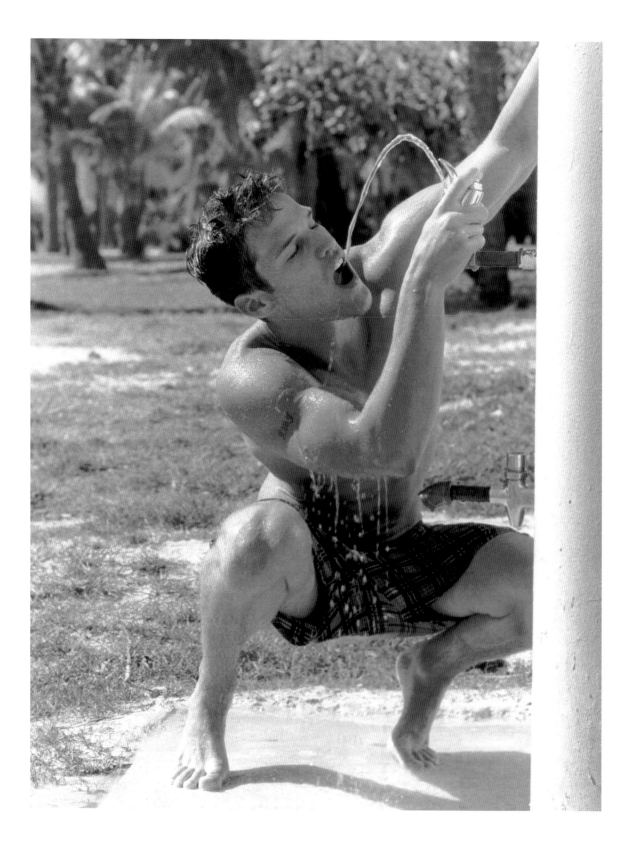

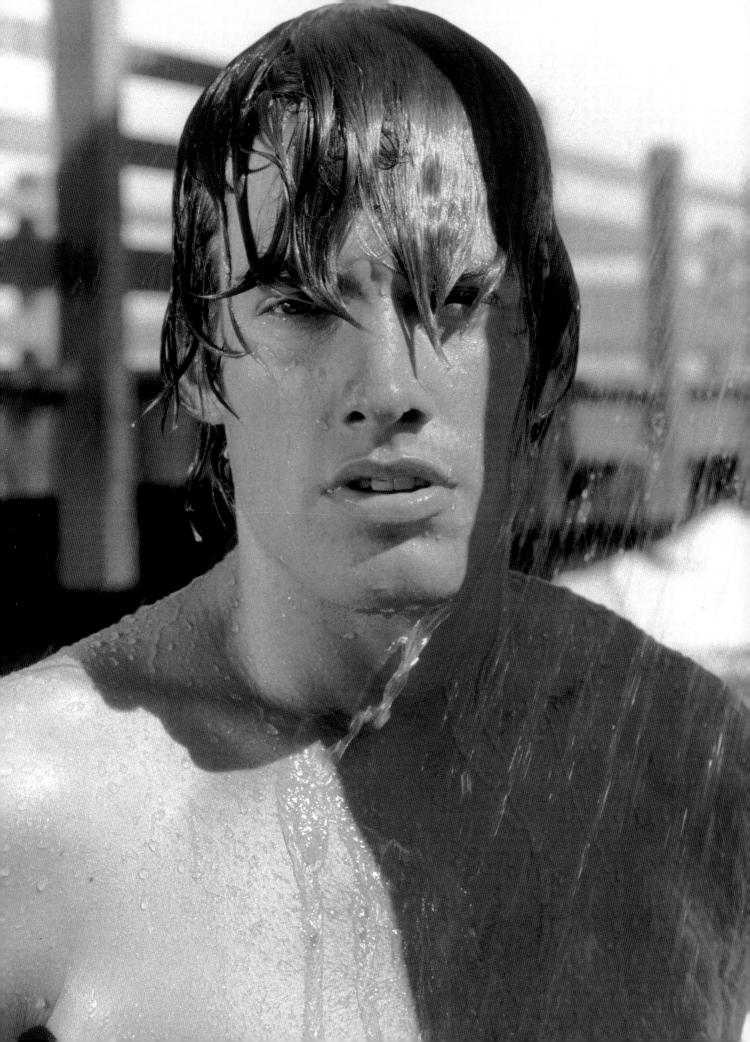

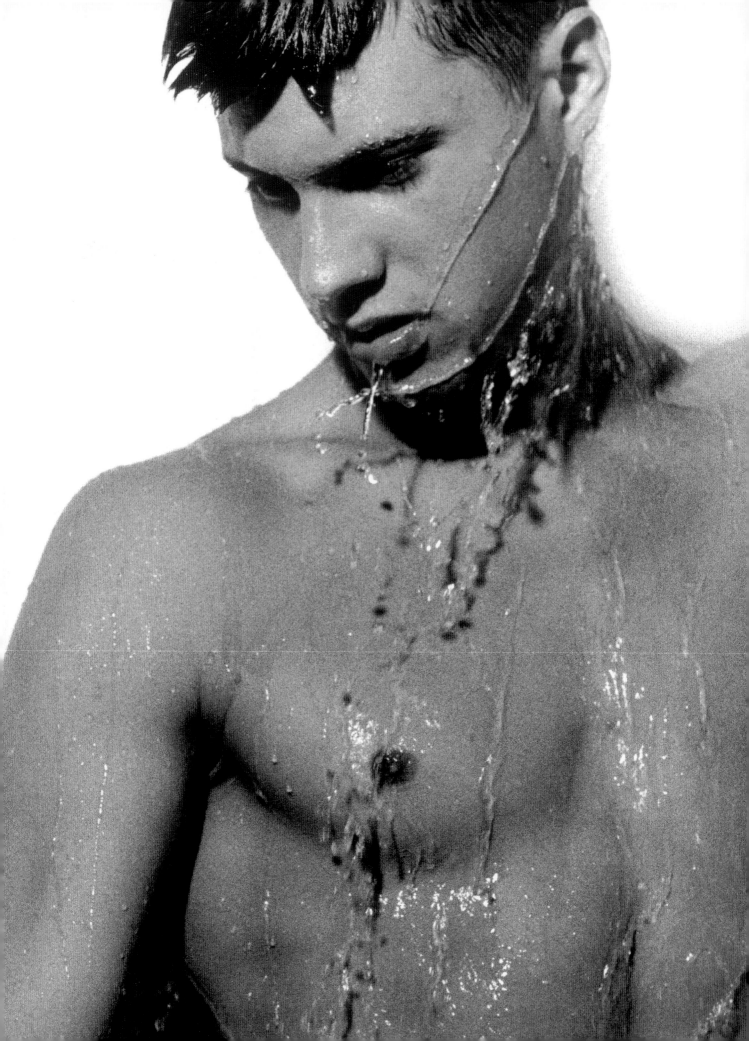

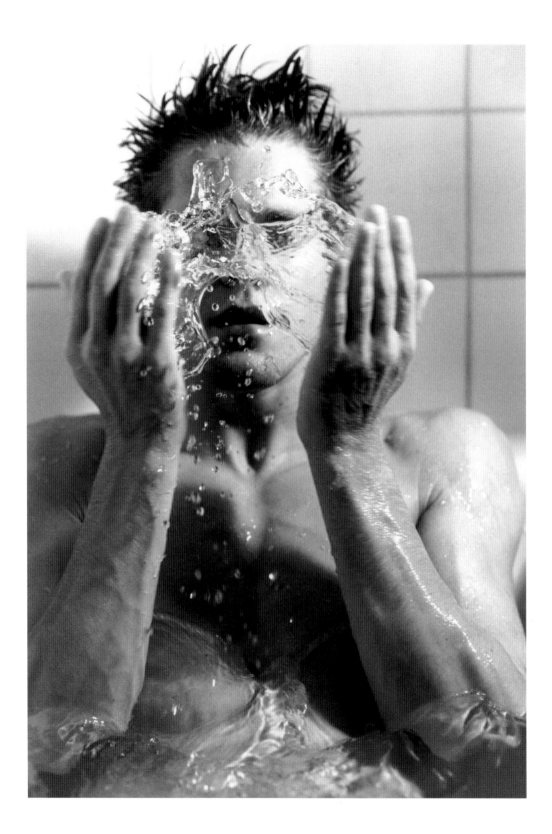

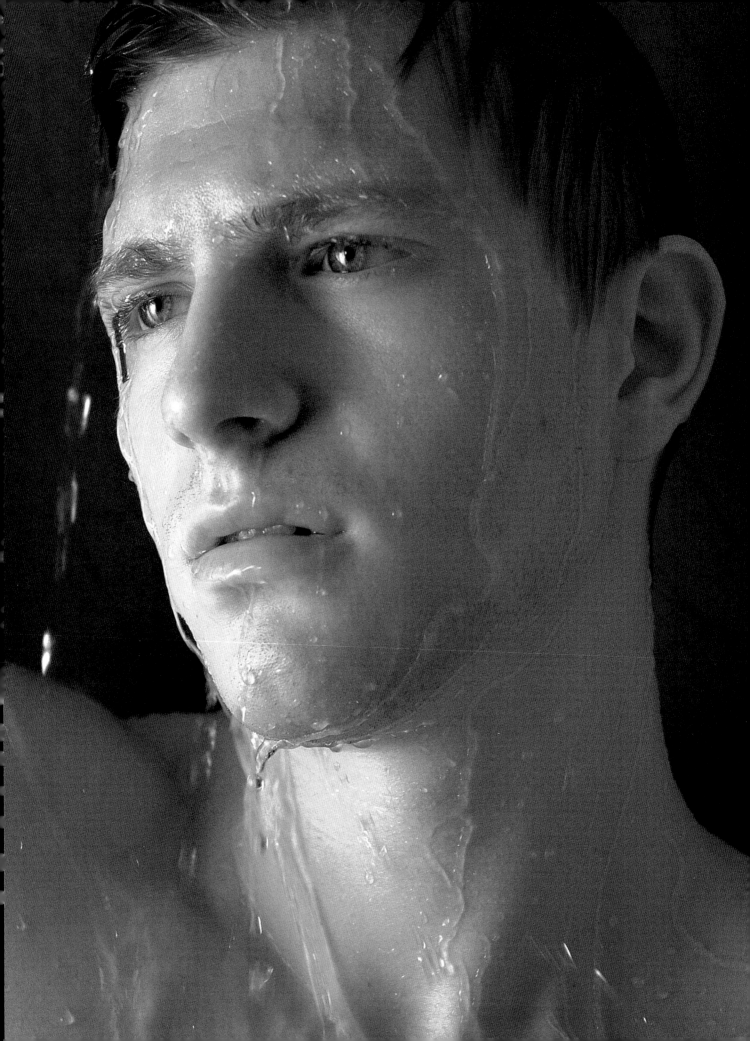

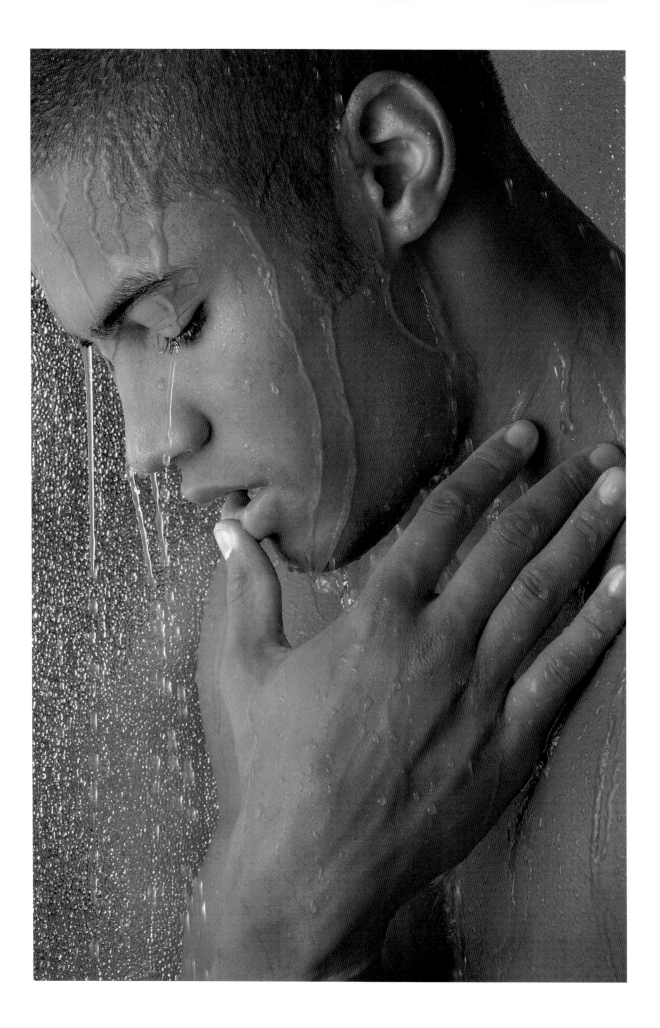

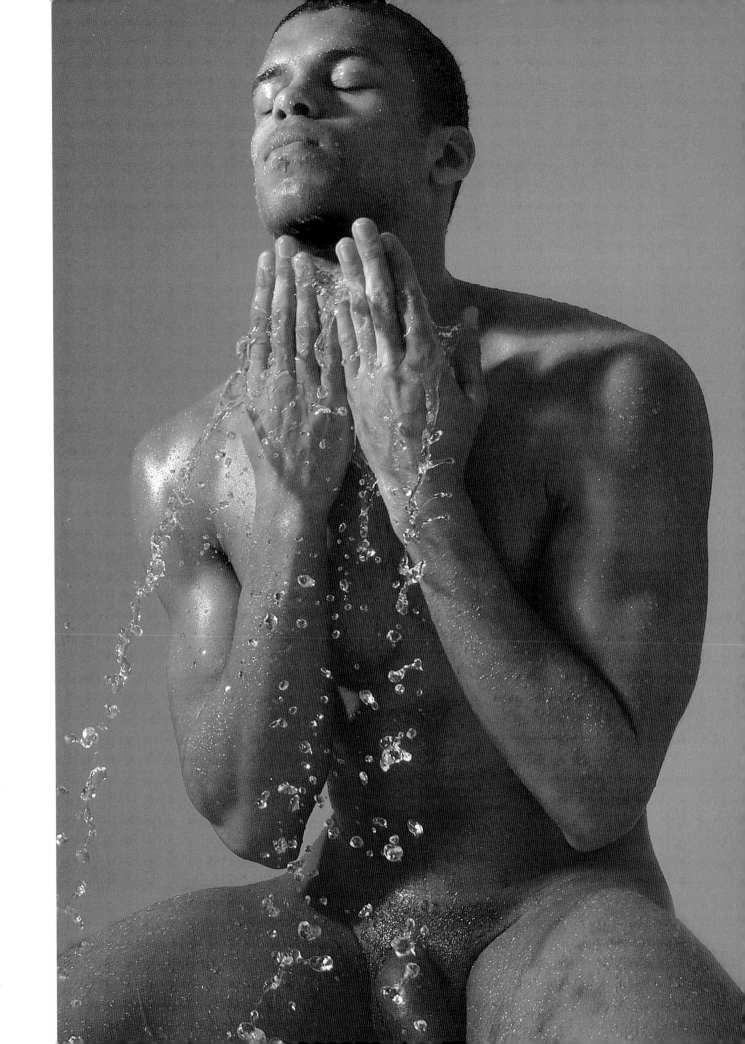

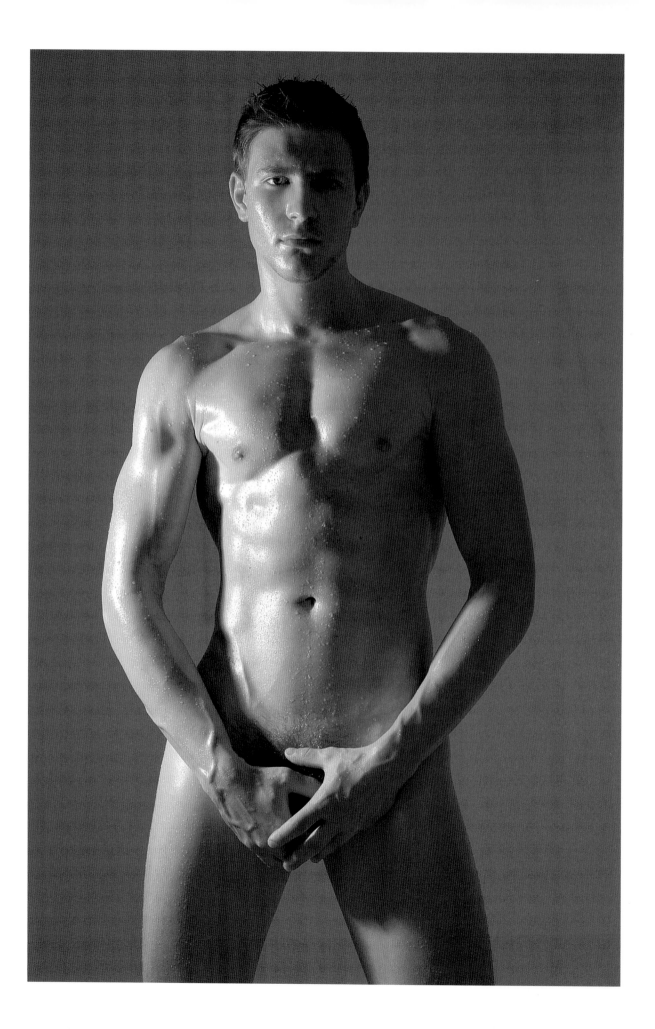

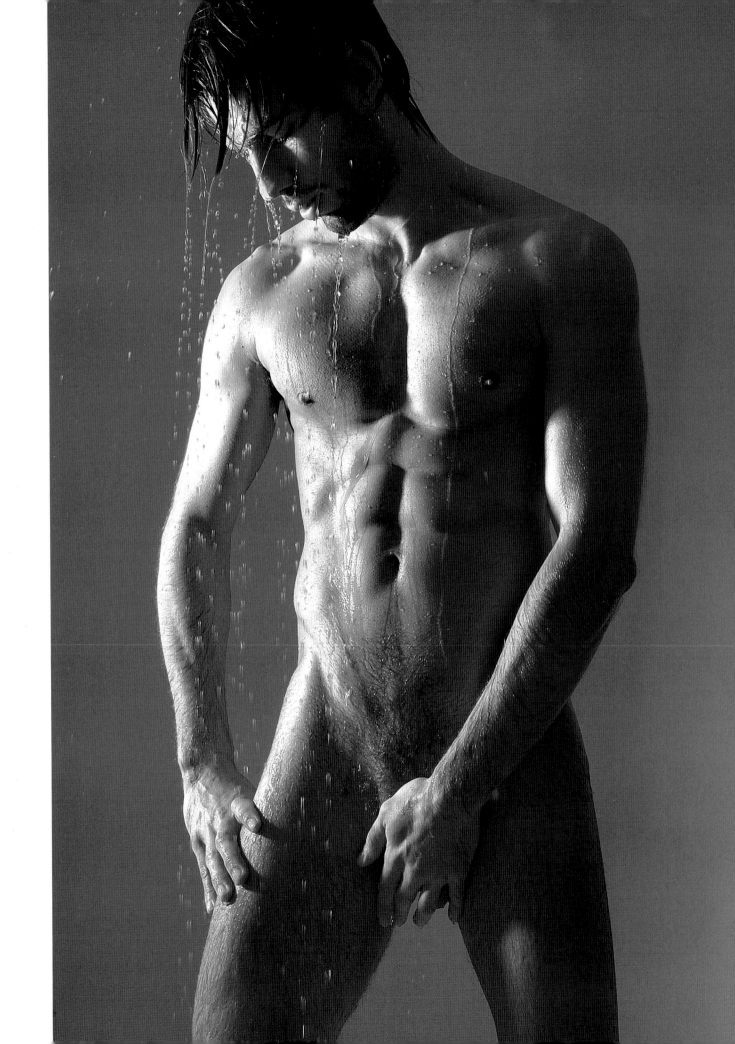

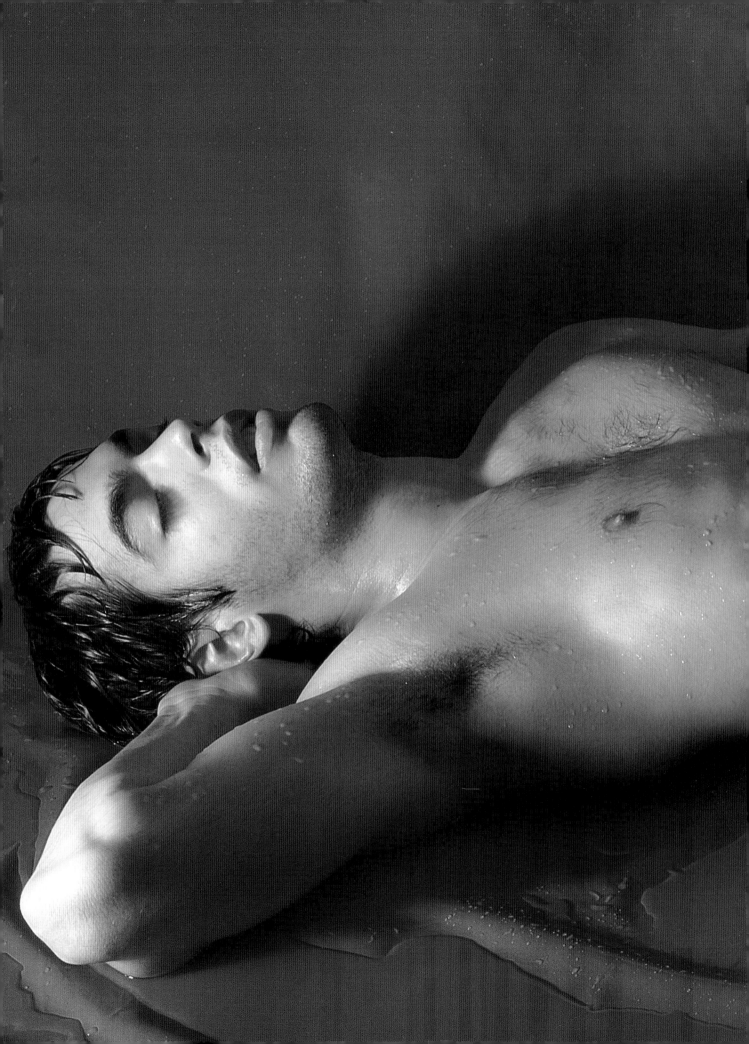

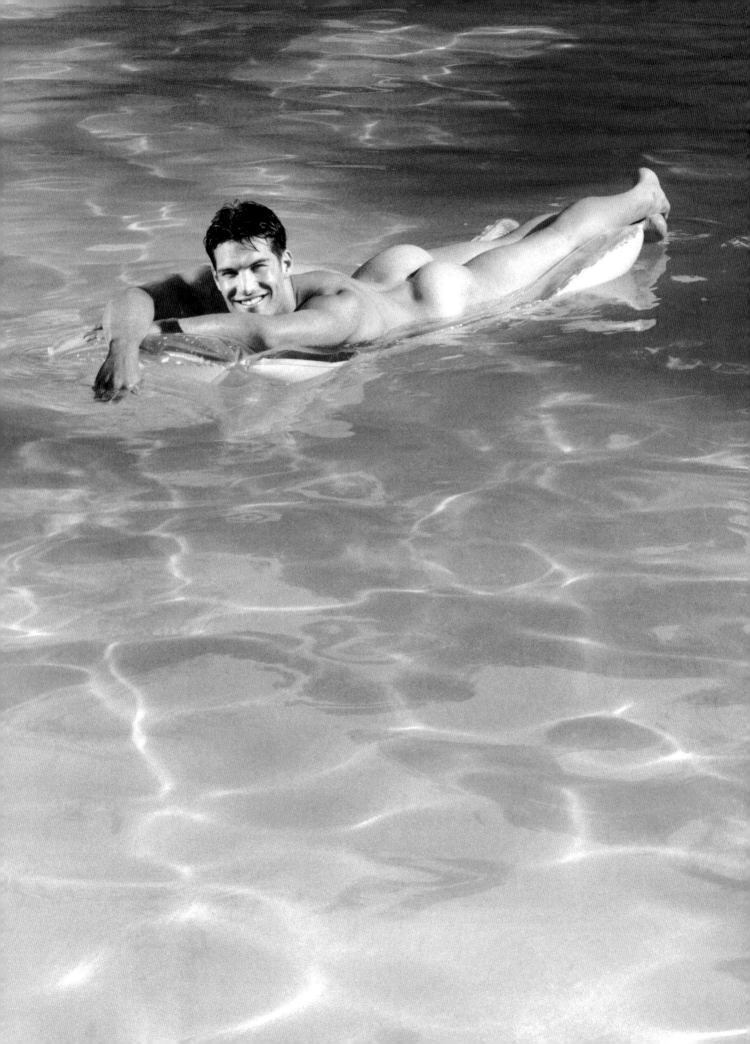

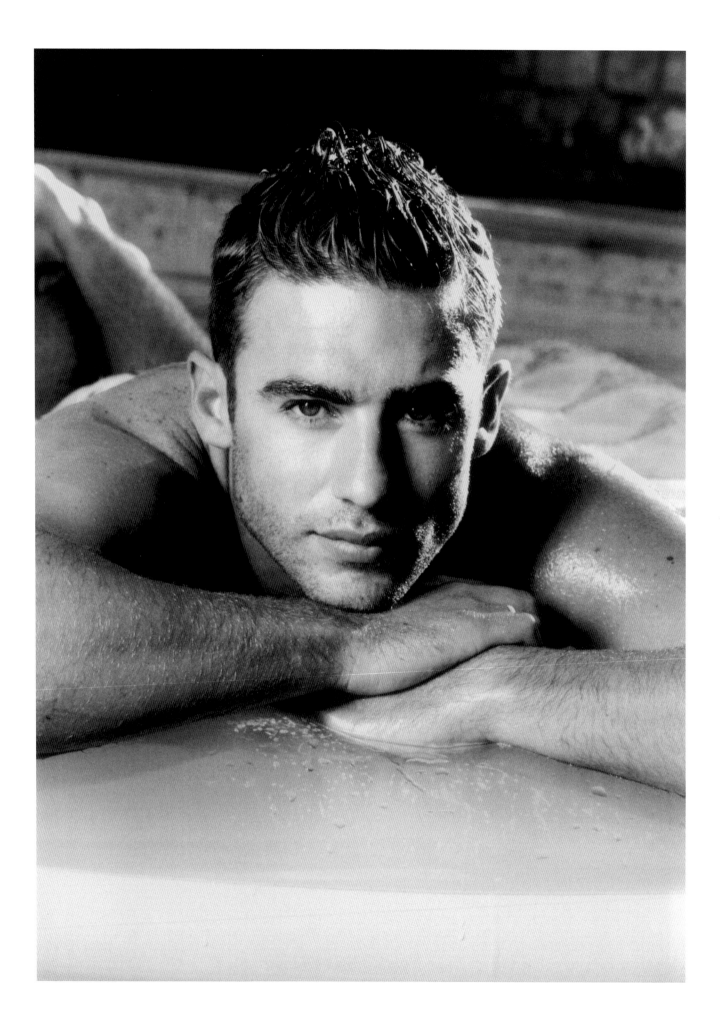

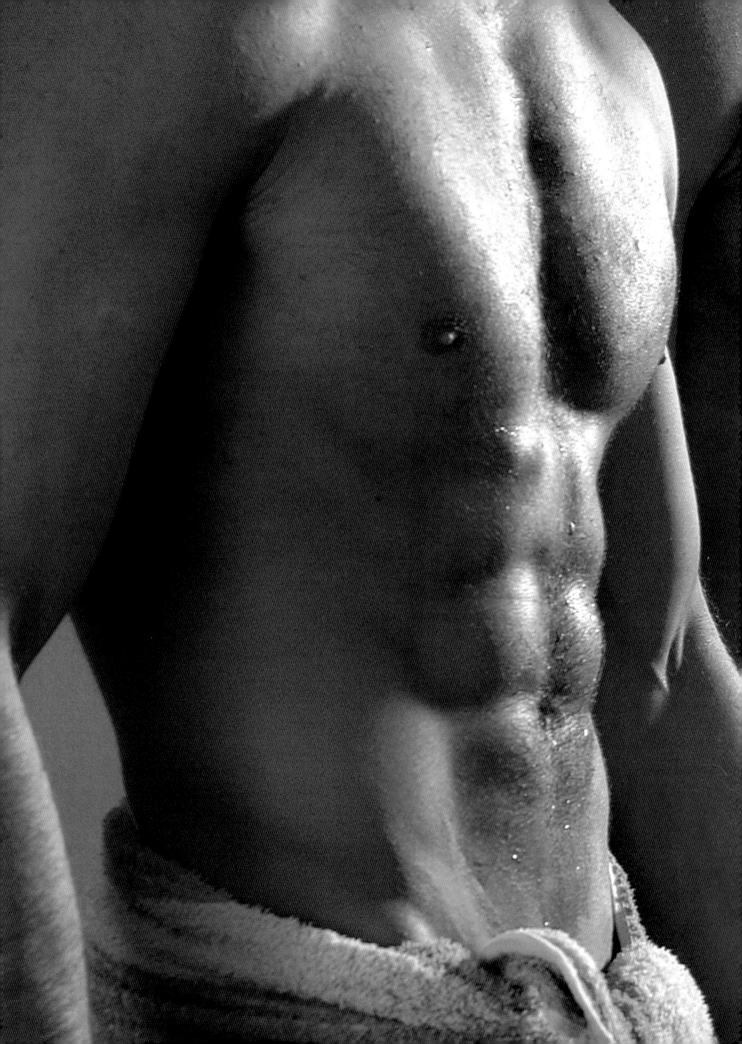

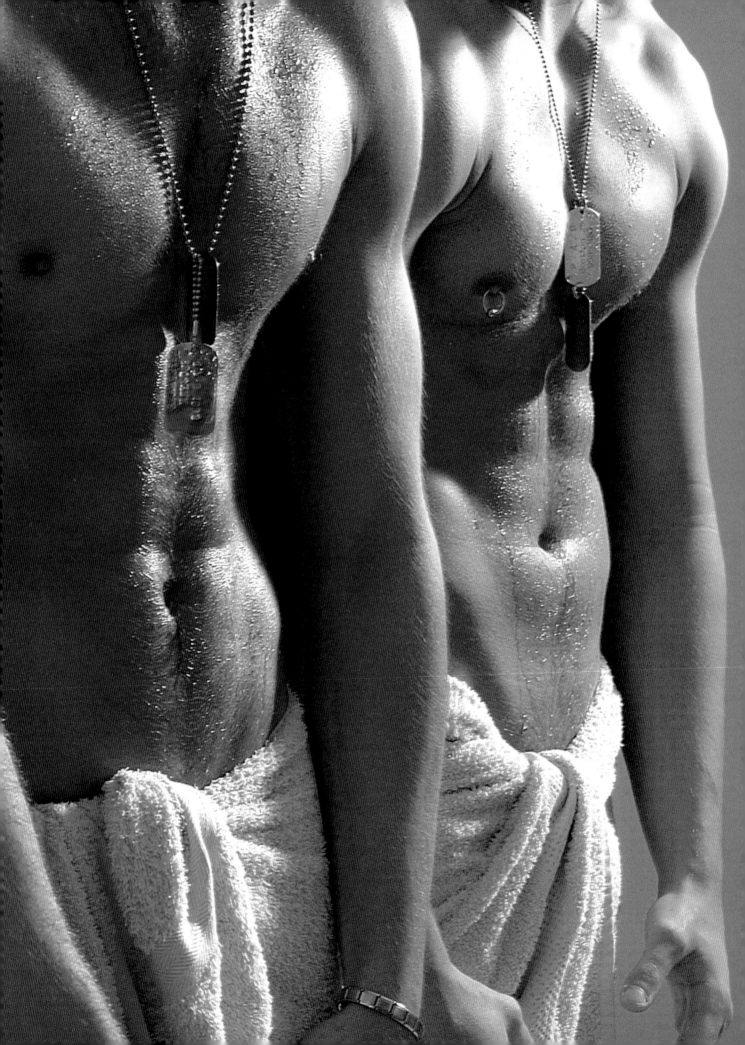

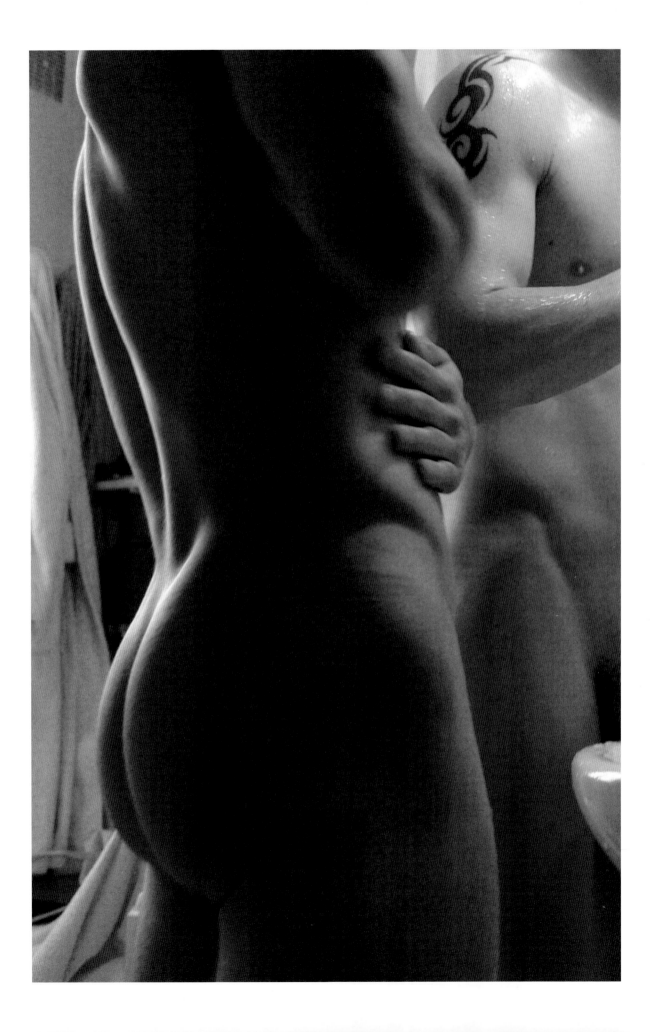

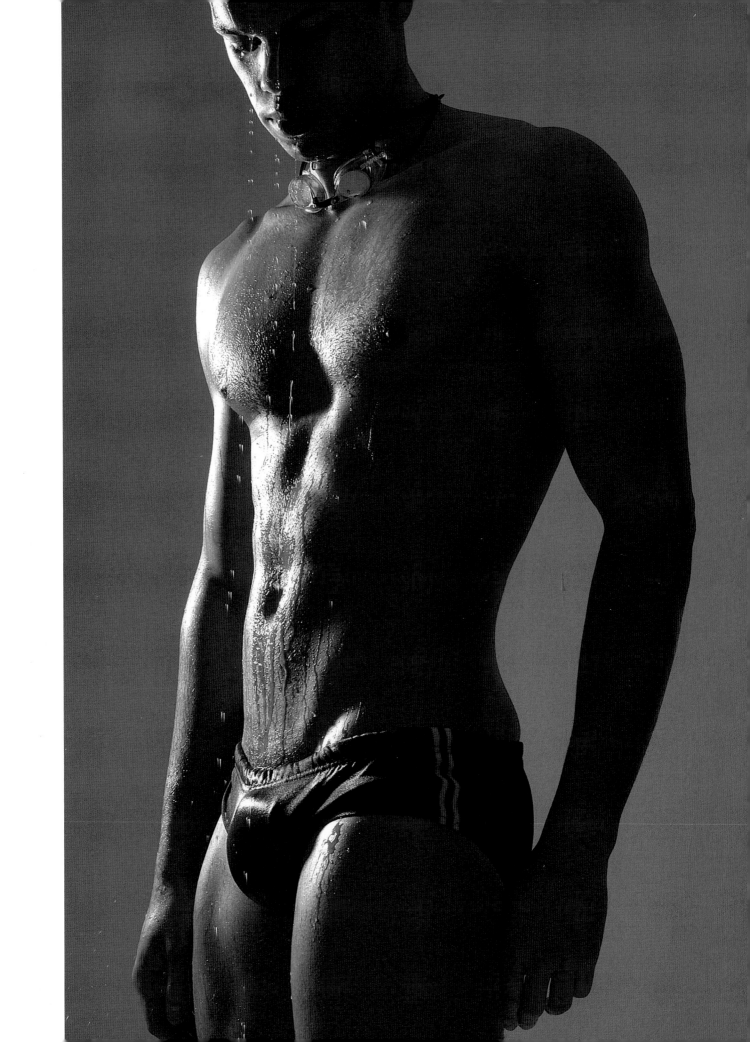

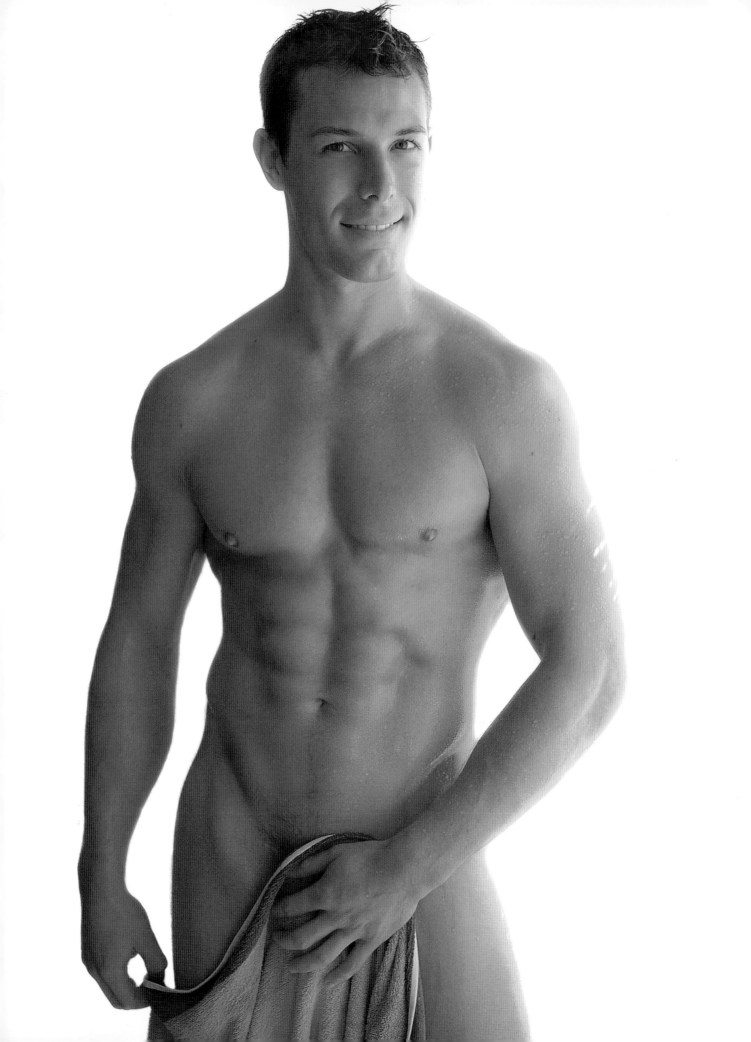

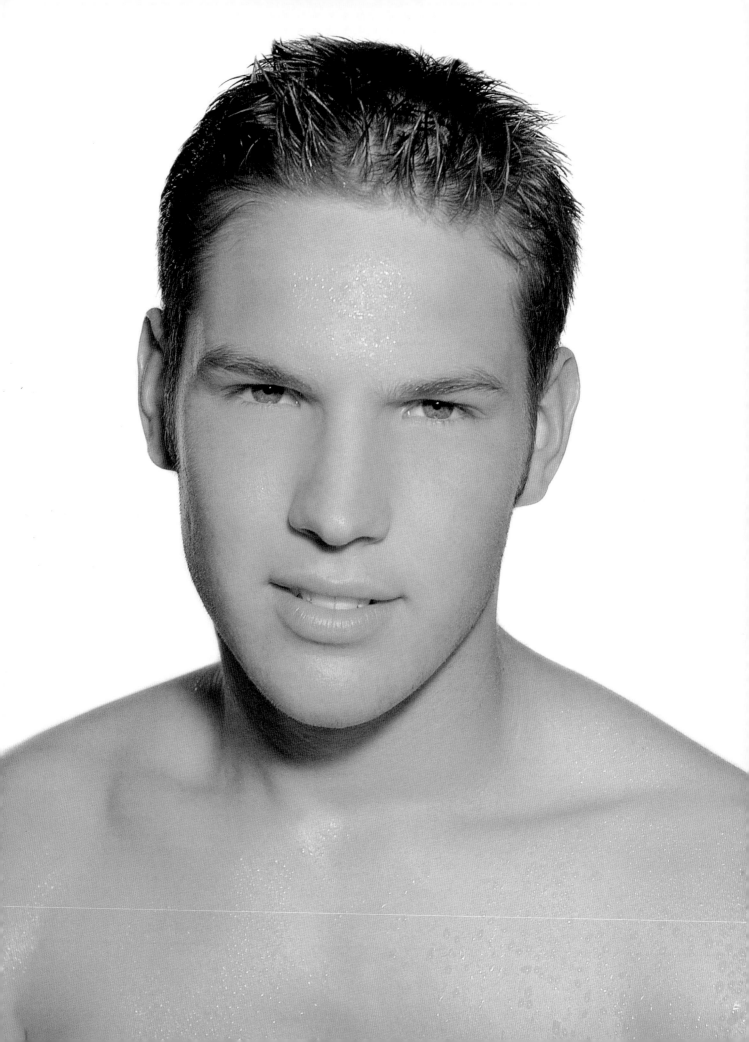

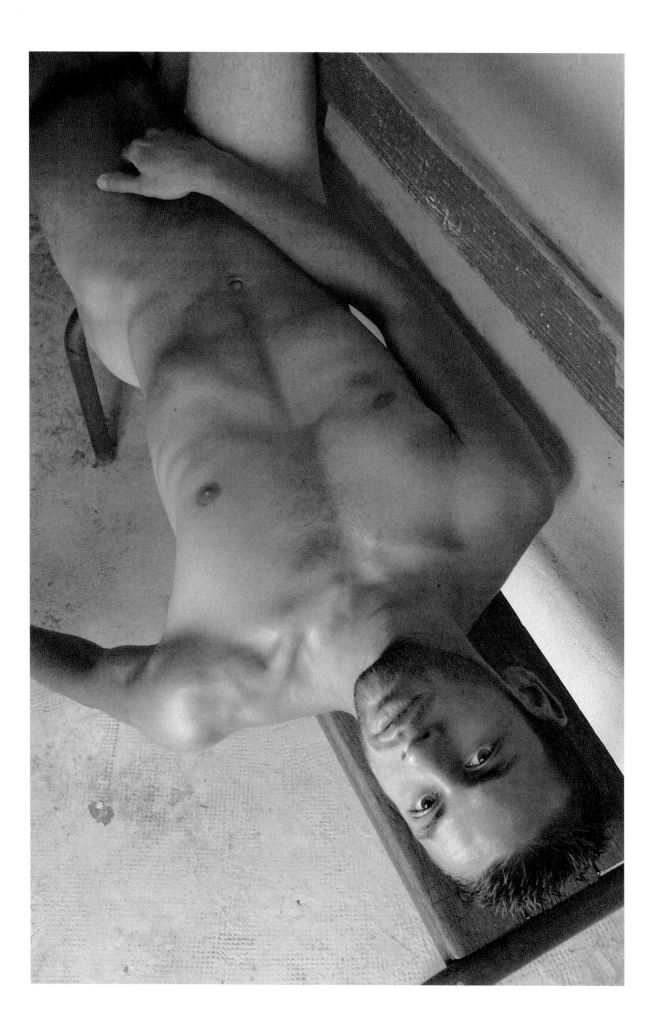

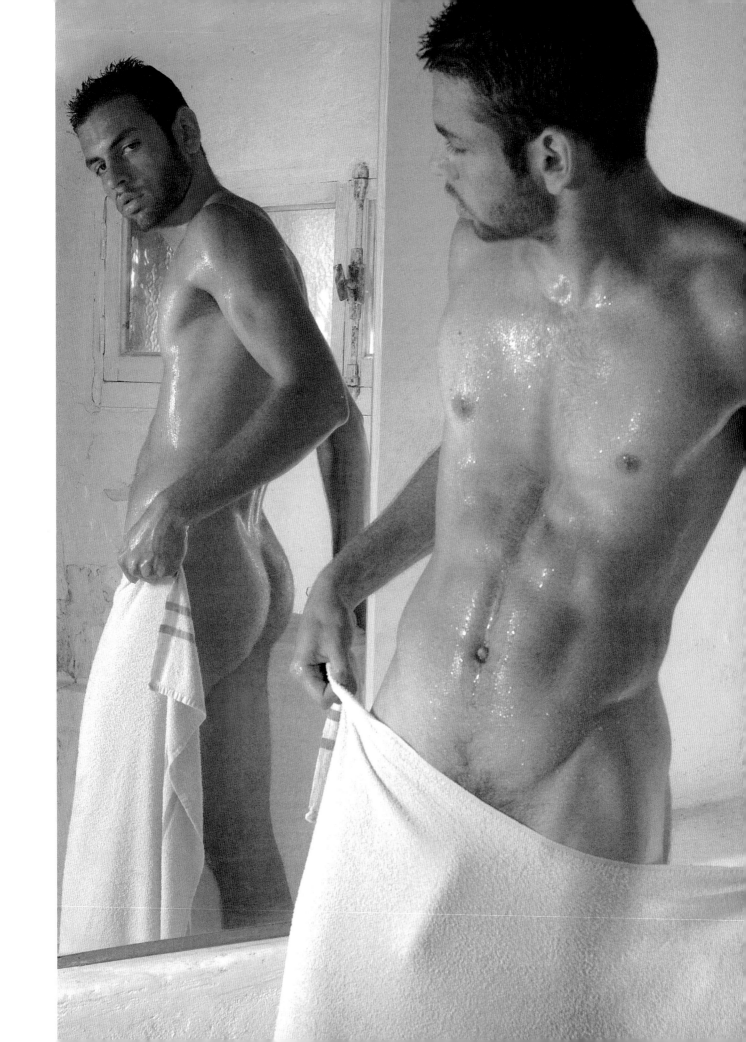

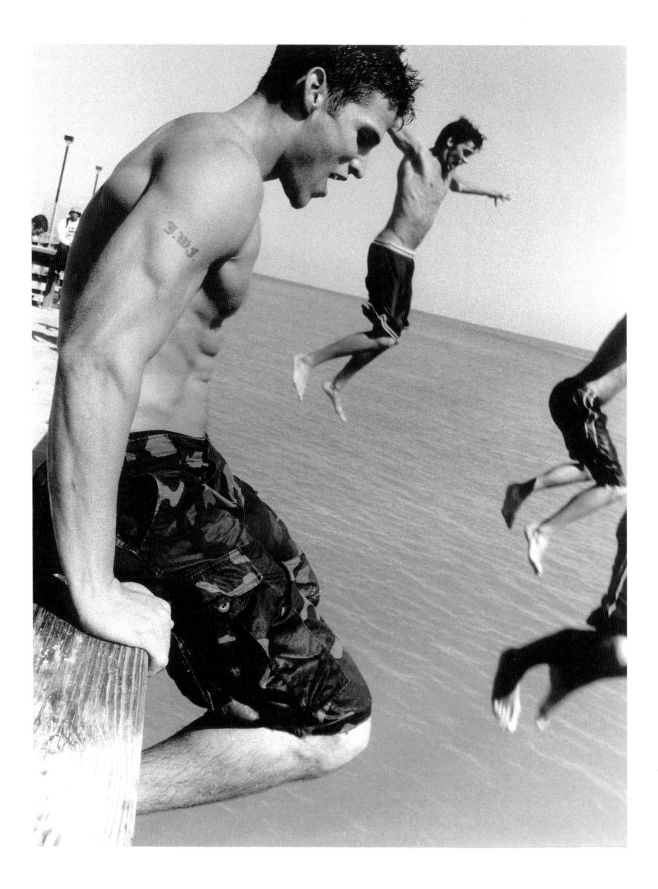

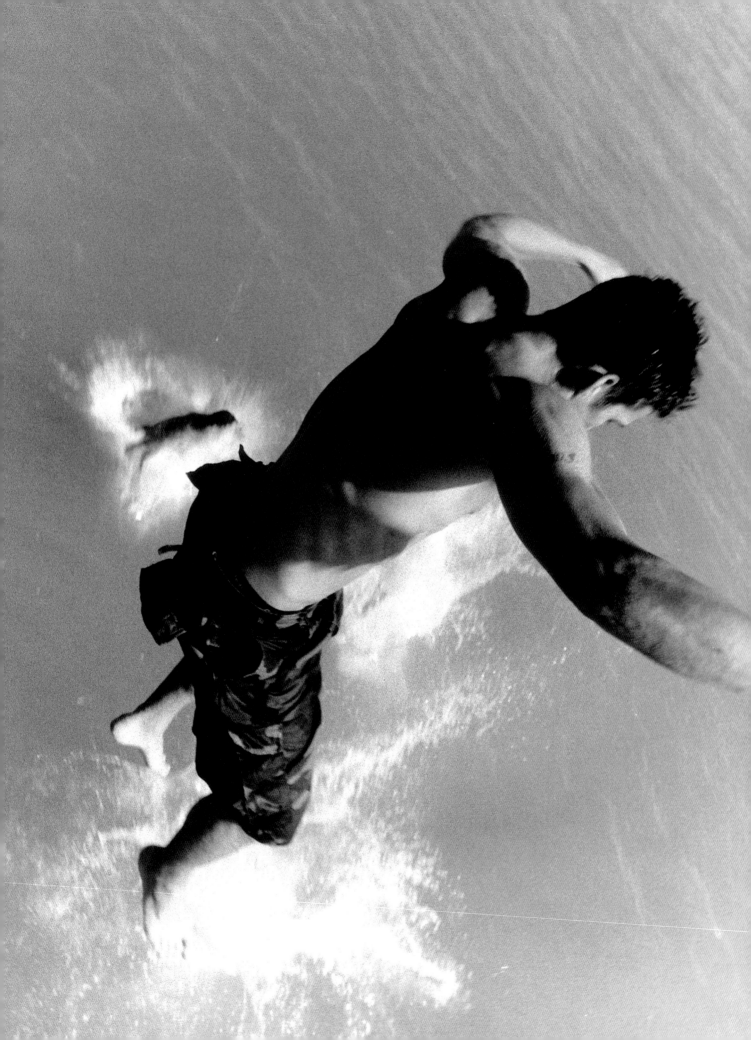

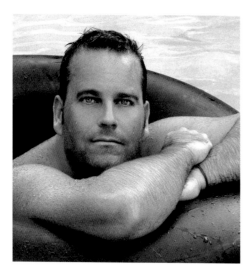

Fred Goudon was born in Cannes in the south of France on June 1st 1965. He studied journalism, worked as a radio DJ and then as a press photographer. He left Cannes at the end of the 80's to go to Los Angeles CA, to be a press correspondent for different magazines and newspapers. It's in Los Angeles that he started doing male model pictures. He came back to France where he still lives, to work as a fashion and commercial photographer. He does male model portfolios for the major model agencies in Paris.

Fred Goudon wurde am 1. Juni 1965 in Cannes geboren. Er studierte Journalismus und arbeitete zunächst als Radio-DJ, dann als Pressefotograf. Ende der achtziger Jahre siedelte er nach Los Angeles über, wo er als Korrespondent für verschiedene Zeitschriften und Magazine arbeitete. Während seiner Zeit in L.A. begann Goudon männliche Models zu fotografieren. Seit seiner Rückkehr nach Frankreich arbeitet Goudon als Mode- und Werbefotograf. Außerdem fotografiert er für die wichtigsten Pariser Modellagenturen deren Setcards männlicher Models.

In memory of
Sylvia
Nat Kelly Cole
Mike Koepsell

Merci à Nathalie Chassat , Grégory Rossi: Art Print.

Merci à Bruno Gmünder, Michael Taubenheim, Claus Kiessling, Joris Buiks, Achim Niedtfeld.

Un grand merci aux models qui ont généreusement et patiemment contribués à la réalisation de ce livre.

Toute mon affection et Mille Merci à:

Gilles Marini (pages 22, 45, 74, 75, 77, 89), George, Carole, Florent & Dimitri Sarasin, Mathieu Aubert (page 111), David, Alexandre, Henry, Isabelle Beynel & Alegria Sicsu, Laura & Isabelle Hassan, Christophe Dubois (pages 65, 66), R.J Belles (pages 2, 58), Angi & Paul: L.A. Models, Claude Caccia (page 67), Yann, Matis, Sophie Vonlanthen, Simon (page 59), Paul Hagenauer, Hakim (page 61), Stephan Junillon, Jim (pages 62, 63), Eric Laffont: Houra Models Nice, Raphaël (pages 76, 88, back cover), Frédéric Blavot (pages 88, 104), Alexis Nash, Michael Fox, Carine Lebrun, Valérie Calazel: le mag des castings, Patrick Léonard: Négatif +, Caroline Liron, Louis Bataille, Manuela, Stan Dabrowicz art work NYC DOLLS (pages 8 & 9) , Corinne Hemerdinger, Manu Tores Neiva (pages 52 to 56), Olivier Groener (pages 52 to 56): Agence Parallèle, Jorge Cabeza, Martin Prospero, Victor Paiva, Carlos Bouza, (page 48), Federico Bonalpeche (pages 48, 79, 80, 81), Jimena, Maria Raquel, Diego Rios Modelos: Montevideo Uruguay, Robert Vescio, Dominike Duplaa, Fabrice Dandraën, Éric Perceval: Contre Bande, Sport Models, Pascal S (page 64), Pierre Landy, Benjamin & Célia Cornil-Vial, Ricardo, Mathis, Valérie Caritoux, Lena, Maud, Marc-Emmanuel Vuaillat, Isabelle & Franck Meriene, Franck Merenda, Vincent Fournier (pages 26, 27), Aurélien Roulin, Éric Saramagna (pages 22, 23), Madji & Aymeric Boussuge, Guillaume et Tom, Franck Herbert (pages 30, 31), Thomas Gasperini, Ronald, Mathieu & Gabriel Morizet (pages 29, 69), André: Phidias Gym le Cannet, Sandro Leal Ruviaro (pages 42, 43, 47), Hôtel Bel Air Casteldefels, Daniel (page 16), Cyril (page 17), Monsieur & Madame Husa (location pages 68, 70, 71), Vilma, Tomas Husa (pages 71, 72, 73, 120), Niklas (pages 72, 73, 120), Mikko (pages 72, 73): Fondi Helsinki, Frederick Malahieude (page 32), Paola Rebeiz, Johann Tsesemeli (page 105), Jon Sheridan (pages 38, 114), Justin Falkowitz (pages 92, 114, 115), Adam Williams (page 93), Barbara Newman: Ford Miami, Christian Copin, Cyril Thévenot (page 98), Pierre Leander, Jan Kaiser, Christophe & Pierre Raygot, Mia & Scott Dequine, Chris (page 14), Marc (page 10), Tino: Irene Marie Miami, Riad (page 39), Stone, Xavier Lacroix (pages 8,9), Caroline Mazzoni, Yannick A (page 86), Stéphane Bono (page 25), Yoann Arnaud, Côme Bardon, Alexandre Montez (pages 34, 35), Sacha & Caroline Saslawsky, Thomas Schmidt (pages 6,7), Pascale et Bernard Fouquet, Pascal (page 11), Jean Poderos, Jean-Charles Mougenot, Stephane Szczykz, Alex Roberto (pages 106, 107), Soukeyna & Kris, Anne-Gaelle, Kriis (page 20), Nicolas Jeanniot, Sofiane (page 5), Luc Bellone, Marc Dansou (pages 99, 109), Sébastien Neveux, Aurélien & Adrien Duris (page 78), Orphée, Sébastien Valla (pages 18, 19), Robert Piotrowsky, Fab (page 44), Johnny Amaro, Laurent Leray (pages 36 & 37), Laura Favali, Florian Chatelain, Sylvain (page 96), PDB, Nico Vrban, Guillaume & Cédric (page 108), Marc Valentin, Maor, Jean Suen (page 119), Franck Dangereux, Johann Denebehay, Alexis Rivière, Julien Delargilliere (pages 97, 100), Axel Dofing, Christophe Mahen (page 91), Bruno Vidal, Christophe Precigout, Florent Belmon (pages 49, 50, 51), Christophe Éclipse, Fabio Leone, Frédéric Marty, Gilles Couturier (pages 4, 15, 57, 82, 85), Samir Delucas, Benjamin Le Duff (page 95), Yves Boulanger, Julien Farcat (page 101), Frédéric H, Julien (pages 12, 13), Alain Yapoujian, Grégory Guillou-Montean (page 33), les Fadas-Paruit, Frédéric Begin (page 110), Troy Doxey, Johannes Hayek (pages 112, 113), David Hauschild, Koepsell family, Fabien Charlier (pages 102, 103), Barbara, Shahrad, Hila and all Tehranchi family, Vincent Frobert (cover, pages 40 & 41), Joel West, Fabrizio Alaimo (page 83), les Rossi, Buzz, Killian, Greg (pages 1, 24, 87, 90), ma famille, Claude, Régine, Stéphanie, Julia, Sébastien Perez, Georges & Renée Goudon.

Locations: Vallauris, Golfe Juan, Cannes, Le Cannet, Mougins, Cap D'Antibes, Cap Ferrat, Barcelona, Casteldefells, Ibiza, Punta del Este (Uruguay), Helsinki, Tempere (Finland), Miami, Los Angeles, Paris

Contact & website : www.fredgoudon.com

05 06 07 / 5 4 3 2 1
ISBN 3-86187-949-2

© 2005, Bruno Gmünder Verlag GmbH
Kleiststr. 23-26 · 10787 Berlin · Germany
Phone: ++49 (30) 615 00 30
E-mail: info@brunogmuender.com

All photographs copyright © 2005 Fred Goudon, France

Coverdesign: Frank Schröder
Edited by Claus Kiessling
Production: Joris Buiks
Printed in Italy

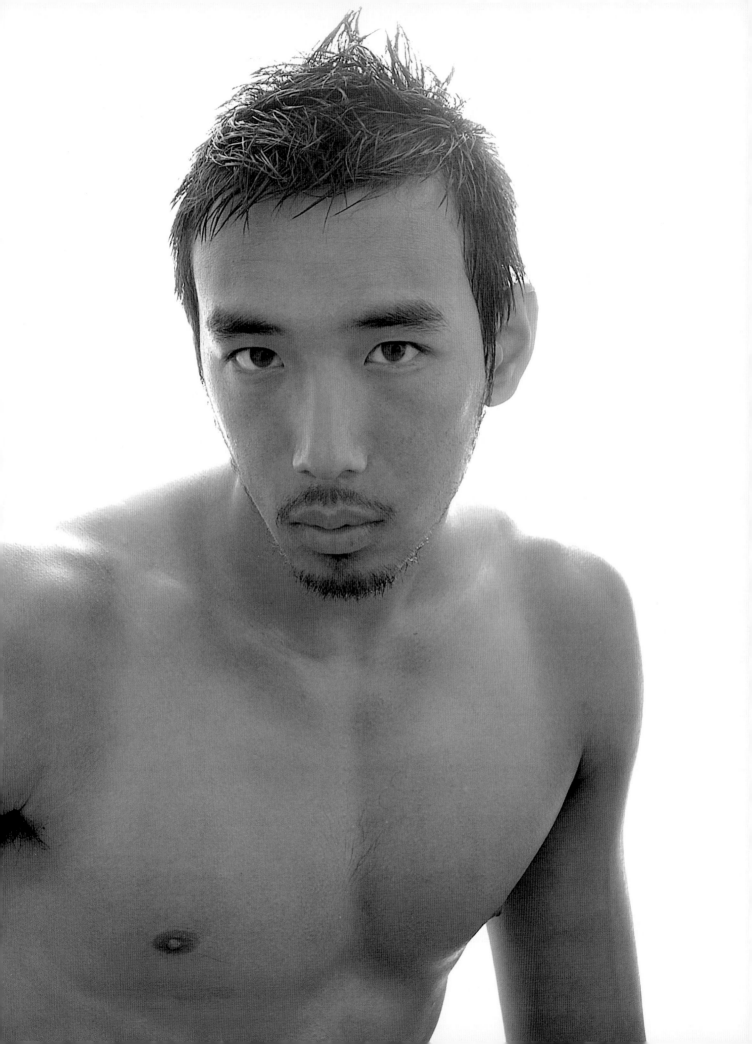

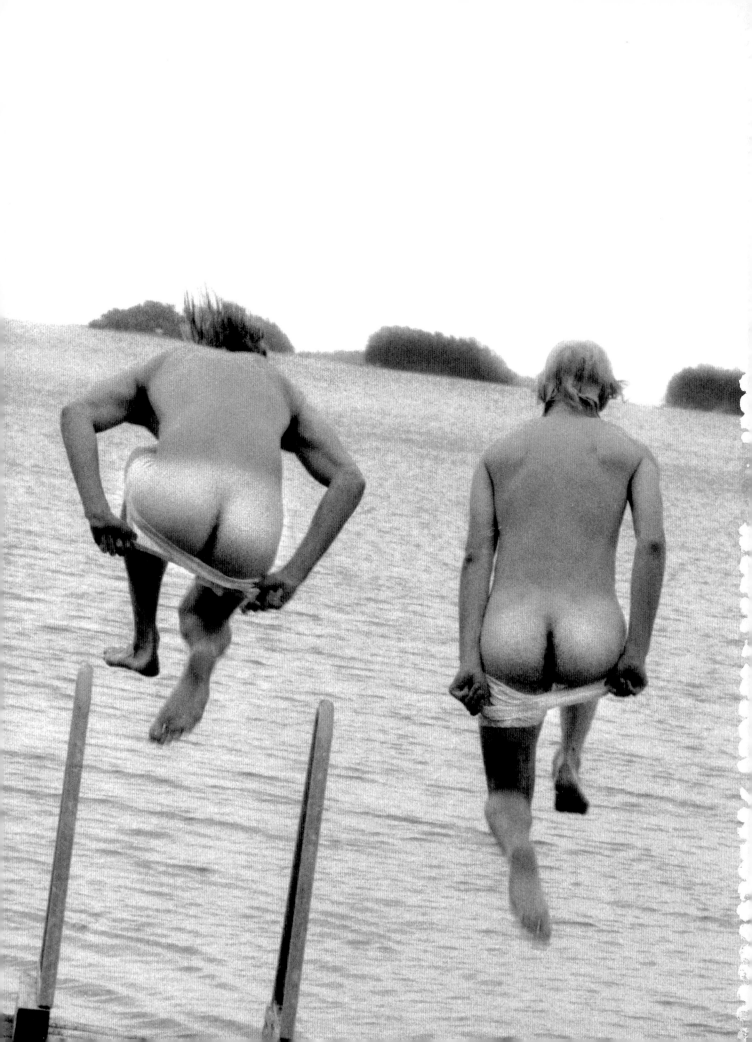